Adventures in Photography

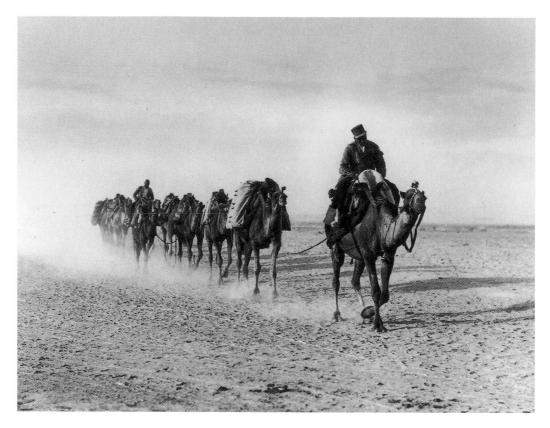

Frontispiece. Rayy, Iran, 1934–38. Camel caravan on the plain of Rayy. The fertile band between the Elburz Mountains to the north and the desert to the south has been from earliest times a corridor between east and west.
Photograph by Stanislaw Niedzwiecki (neg. S4-144002)

Adventures in Photography

Expeditions of
the University of Pennsylvania Museum
of Archaeology and Anthropology

Alessandro Pezzati

University of Pennsylvania Museum of Archaeology and Anthropology
Philadelphia

Cataloging-in-Publication data available from U.S. Library of Congress.
ISBN 1-931707-41-3

Alessandro Pezzati is Archivist at the University of Pennsylvania Museum of
Archaeology and Anthropology.

Printed in the United States of America

Contents

Plates

Foreword

Since 1887, the University of Pennsylvania Museum has been one of the leading archaeology and anthropology museums in the world and has sponsored field research in every corner of the globe. The Museum is justly proud of the many kinds of treasures its expeditions have revealed. Obviously, the research has yielded many of the more than one million material pieces that grace the Museum's collections today. These objects, which were made over huge spans of time and space, from periods that date thousands of years in the past right up to the present day, reveal the incredibly diverse material accomplishments of peoples the world over.

But the Museum's research has resulted in other treasures, such as the plentiful field notes, maps, and drawings that make the Museum's archives a unique repository in its own right. These documentary materials, in conjunction with the objects, have facilitated countless studies and analyses that have provided us perhaps the most important treasure of all: scholarly insights into the nature of the peoples and their cultures that produced the objects (and the dissemination of these new understandings to all our audiences through publications, exhibits, and public programs).

Another key outcome of the Museum's fieldwork, from its first expedition to Nippur in modern-day Iraq to its current research in fifteen countries throughout the world, has been a wealth of photographs of archaeological explorations and excavations, as well as images of modern peoples in every inhabited continent of our planet. These photographs, in the hundreds of thousands, range from mundane record-keeping pictures to glorious aesthetic treats and are in great demand by our own scholars and students and by researchers and publishers worldwide.

The Museum is grateful to Alessandro Pezzati, the Museum's archivist, for choosing the wonderful examples from this photographic treasure trove that grace this volume. He also has written an informative overview of the field research that produced these photographs.

The Museum also is sincerely grateful to Douglas Walker, a member of the Museum's Board of Overseers, for his generosity in helping make this book possible. It is further delighted to acknowledge Andrea M. Baldeck, M.D., also a member of the Board, and William M. Hollis, Jr., for their wonderful support of the exhibit of photographs in the new Annette Merle-Smith Gallery, from which this volume derives.

The book is dedicated to A. Bruce and Margaret Redfield Mainwaring. I deeply admire Bruce and Peggy for their understanding of and love for the Museum and its mission and for their inspirational support of its activities; I know that my admiration is widely shared by staff and friends of the Museum alike. This book is a small "thank you" for all that they have done for the Museum.

JEREMY A. SABLOFF
The Williams Director
University of Pennsylvania Museum
 of Archaeology and Anthropology

Adventures in Photography

Adventures in Photography

Romantic tradition in the western world pictures primitive communities as exciting combinations of colorful dress, bizarre customs, and sinister rites. Anthropologists, who make it their business to study these communities, are used to finding their inhabitants normal human beings most of whose time is concerned with the daily requirements of making a living. Furthermore, they are dedicated to the job of showing how the seemingly bizarre and sinister are after all devoted to the accomplishment of mundane ends. Sorcery turns out to be important in law enforcement where police and jails are wanting; elaborate initiation rites at puberty serve to dramatize the seriousness of adult responsibilities; and mysterious secret societies turn out to be social or political clubs which operate very much like our own lodges and brotherhoods. Thus anthropologists find themselves in the role of debunkers of the romantic view of primitive man.

> Ward H. Goodenough, "The Pageant of Death in Nakanai: A Report of the 1954 Expedition to New Britain," *University Museum Bulletin* 19(1) March 1955:19.

Since its founding in 1887, the University of Pennsylvania Museum of Archaeology and Anthropology has undertaken a program of fieldwork and exploration around the world that continues to this day. The collection of firsthand observations and evidence of human and material culture has been essential to the Museum's mission of discovering and explaining the immense diversity and depth of the human experience, past and present.

The science of anthropology grew out of the age of European exploration, discovery, and conquest that began during the Renaissance and

reached its apex in the 19th century. Contact with a variety of foreign peoples, as well as the unearthing of such lost cities and civilizations as Pompeii, Troy, and Mycenae, required new frames of reference and interpretation. The formulation of the theories of geologic time (as opposed to Biblical time) and the evolution of species had an immense effect on the early explanations of human variation around the globe. Although many of the first theories stressed the superiority of Western civilization and were based on racist models of human progress, by the end of the 19th century anthropology had adopted a relativistic view of culture that examined each culture in its own context and searched for explanations in the variety of experiences unique to each culture. Around this time the disciplines of archaeology and anthropology became part of professional scientific programs sponsored by academic institutions, and fieldwork became the central practice for acquiring information about human cultures.

The University of Pennsylvania Museum is one of the world's foremost sources of information about the history, nature, and significance of the world's cultural heritage. Through its research programs, its world-class collections of artifacts, and its exhibitions and publications, the Museum contributes to the advancement of knowledge in the fields of archaeology and anthropology. Over the years the Museum has helped to shape and develop these disciplines with its ongoing research and education programs.

The Museum was created as a repository for the collection, display, and study of specimens acquired by its own field expeditions. Over the years many of its artifacts were also obtained through purchase or donation, but the greater portion of its collection was documented by scholars and field researchers, adding greatly to the intellectual value of the objects.

In its effort to learn about the origins of human societies and to produce significant knowledge about the human past and present, the Museum has conducted about 350 expeditions to all parts of the world, from Iraq to Alaska and from West Africa to Siberia. The Museum's program of fieldwork remains one of the most active and comprehensive in the world today.

The Museum's Expeditions

Near East

Between 1889 and 1900 the Museum was the first American institution to carry out archaeological excavations in the Near East. The expedition to the site of ancient Nippur in Mesopotamia (Iraq), organized by John P. Peters, funded by the Babylonian Exploration Fund, and directed by Peters and Herman V. Hilprecht, revealed a library of inscribed cuneiform

tablets that have formed the basis of our understanding of the first literate society in the world, the Sumerians. The photographs by John Henry Haynes show Arab workers removing dirt in baskets to reveal portions of the ruins (Plate 1). A surreal landscape is painted by the fragments of architectural remains of what was once a great city (Plate 2). Haynes learned photography from William J. Stillman, an American artist and photographer who had published a pioneering photographic study of the Athenian Acropolis in 1870.

The city of Beth Shean, Israel, was one of the greatest and most powerful cities of ancient Palestine. It is situated at a crossroads between the lands of the eastern Mediterranean and the rest of the Middle East. Museum excavations at this site were conducted between 1921 and 1933 and established the archaeological sequence for dating this entire area (Plates 18 and 19). Beth Shean's history is remarkably long: it has been inhabited from Neolithic (ca. 5000 B.C.) through Byzantine and Arab (ca. A.D. 1200) times. The city was conquered by Ramesses II, marking the northernmost point of expansion of the Egyptian empire. The excavations provided much material for the study of Canaanite religion.

One of the Museum's most noteworthy archaeological projects was its Joint Expedition to Ur with the British Museum, under the leadership of the famous British archaeologist, C. Leonard Woolley. He excavated for twelve consecutive seasons between 1922 and 1934 (Plate 34). The birthplace of the Old Testament patriarch Abraham, the site yielded cuneiform tablets and a rich architectural history dating back to 3000 B.C. The most stunning finds were the Royal Tombs, dating to 2650–2550 B.C., which contained a wealth of objects made of gold, lapis lazuli, carnelian, and other semiprecious stones. These grave furnishings of the kings and queens of Ur represent the highest artistic achievement of the Sumerians.

Other important work in Iraq continued with the excavations at Tell Billa and Tepe Gawra, in northern Mesopotamia (1930–38), led by E. A. Speiser and Charles Bache. In 1937 and 1938 Speiser took over from the University of Chicago the excavations at Khafajah, a Sumerian site along the Diyala River in central Iraq known for its fine alabaster and limestone statuettes. Between 1948 and 1952 work was resumed at Nippur with the Oriental Institute of the University of Chicago, which later assumed the project. Theresa Howard Carter excavated at Tell Al-Rimah in 1963.

In 1931 Museum archaeologists were the first Americans to excavate in Persia (Iran), at the site of Tepe Hissar. Under the direction of Erich F. Schmidt, the excavations revealed Tepe Hissar as an important trading site from earliest times on the route to and from central Asia. The photography of Stanislaw Niedzwiecki captured stunning views of work at the site (Plates 23 and 25). He also photographed people and scenes in the nearby town of Damghan (Plates 27 and 28).

Between 1934 and 1937 Erich Schmidt continued his work in Iran with excavations at the Islamic city of Rayy (A.D. 637–1220) and at surrounding prehistoric occupations (frontispiece). He also conducted an aerial survey to locate archaeological sites and took over the directorship of the University of Chicago's work at Persepolis, the capital of the Achaemenid Persian Empire under Darius the Great.

The archaeological project at Hasanlu, a site in the Azerbaijan province of northwestern Iran, was directed by Robert H. Dyson, Jr., from 1956 to 1977. The main occupation level dates to the Iron Age (ca. 800 B.C.) and revealed that the city had been invaded, sacked, and burned, possibly by Urartian assailants, around this time, leaving behind a horrific picture of destruction (Plate 62).

Another important site in southwest Iran, Tal-e Malyan, identified as Anshan, the highland capital of the Elamites from ca. 3000 to 1000 B.C., was discovered and excavated by William M. Sumner between 1971 and 1978.

Biblical narratives have given much impetus to the study of archaeology. James B. Pritchard's work was devoted to this field. Between 1956 and 1962 he excavated the site of Biblical Gibeon, where the sun stood still for Joshua, located eight miles north of Jerusalem. The famous discovery of the Pool of Gibeon (Plate 53) confirmed the identification of the site. Pritchard also worked at Tell es-Sa'idiyeh, Jordan (1964–67) and Sarafand, Lebanon (1969–74), a Phoenician port known in the Bible as Zarephath or Sarepta. The latter marked the first excavation of a well-stratified urban settlement on the Phoenician coast, previous archaeological work having recovered occupations among their colonies throughout the Mediterranean and only limited information from the homeland itself. The aerial view of the site (Plate 61) was taken by Julian Whittlesey by means of a camera mounted on a hot air balloon.

For many years Brian Spooner studied pastoralism and agricultural practices in the desert and semi-arid regions of Iran, Afghanistan, Pakistan, and northwest India.

Recent Museum work in the Near East has included excavations by Patrick E. McGovern of Late Bronze and Early Iron Age sites in the Baq'ah Valley, Jordan (1977–81), by Richard L. Zettler at Tell es-Sweyhat, a city in northern Syria on the Euphrates dating to 3000 B.C. (1989–), and by Bruce E. Routledge at the large Iron Age site of Khirbat Mudaynat 'Aliya in Jordan. Renata Holod conducted an archaeological/ethnohistorical survey of the island of Jerba, Tunisia, studying changes in settlement patterns throughout its history. Fredrik T. Hiebert is active with two projects that focus on the development of trade across Eurasia, directing excavations at Anau, a Silk Road settlement in Turkmenistan, Central Asia, and searching for ancient shipwrecks in the Black Sea and associated trading posts on the Turkish coast.

Egypt

In the early 1890s the Museum was a sponsor, through the Egypt Exploration Fund, of the fieldwork of Flinders Petrie. By 1907 the generosity of Eckley B. Coxe, Jr., permitted the Museum to outfit its own archaeological expeditions. David Randall-MacIver and Leonard Woolley excavated a number of sites in Lower Nubia, including cities, military fortresses, and cemeteries. Randall-MacIver discovered and identified the heretofore unknown culture of the Meroitic people, who lived in this area from A.D. 100 to 300. Plate 8 shows a moment of relaxation at the dig.

After Randall-MacIver left the Museum in 1911, he was succeeded by Clarence S. Fisher. Trained as an architect, Fisher was the Museum's most prolific excavator of ancient Egyptian remains. From 1915 to 1923 he worked at some of the best-known and most important Egyptian sites, including Giza, Dra Abu el-Naga (Thebes), Memphis, and Dendereh. His most famous discovery was that of the Palace of the pharaoh Merneptah (ca. 1236–1223 B.C.) at Memphis, a major royal center spanning several millennia. The palace's painted and inscribed columns, some of which can be seen in the galleries of the University of Pennsylvania Museum, had been buried by thousands of years of sand and dirt until the archaeologist brought the building to light (Plate 14).

The Museum's research program in Egypt has remained one of the most productive and long lasting of any institution in this part of the world. In 1929–32 Alan Rowe directed excavations at the pyramid of Meydum, a Third to Fourth Dynasty site dating to ca. 2600 B.C. Two dramatic views of this work are shown in Plates 21 and 26. The years 1955–56 saw the return of the Museum to Memphis under Rudolf Anthes. In the 1960s Froelich Rainey, Director of the Museum, was instrumental in obtaining United States government funding for the salvage of archaeological sites in Nubia threatened by the construction of the Aswan Dam. At the same time, a joint project with Yale University, directed by William Kelly Simpson of Yale, excavated several sites in the area.

A new program of excavations was begun in the 1960s and 1970s, focusing on all aspects of ancient Egyptian archaeology. The work of David O'Connor and William Kelly Simpson at Abydos, a major center for the cult of the god Osiris, began in 1967 and continues today. Lanny Bell excavated tombs at the necropolis of Dra Abu el-Naga. O'Connor and Barry Kemp studied ancient urbanism at Malkata, a city built by Amenhotep III (ca. 1379–1362 B.C.), the father of Akhenaten. Ray W. Smith, a retired American diplomat, obtained Museum funding to photograph the over 35,000 decorated stone blocks from the lost temple built by Akhenaten (ca. 1375–1357 B.C.) at Karnak and to reconstruct the relief scenes with the aid of computers. Subsequent excavations (1975–78) by Donald Redford identified the original location of the temple.

In addition to the Museum's continuing work at Abydos, now under the directorship of Josef Wegner, David S. Silverman has been excavating and recording inscriptions from Old and Middle Kingdom tombs at the site of Saqqara in northern Egypt since 1992.

Mediterranean

One of the best-documented collections of Etruscan artifacts in the United States comes from the 1895–97 excavations at Narce, Vulci, and other important burial sites in central Italy. Arthur L. Frothingham, Secretary of the American School of Classical Studies in Rome, supervised the work carried out by the Italian excavator Francesco Mancinelli-Scotti.

Harriet Boyd Hawes was the first woman to excavate on the island of Crete, unearthing an entire Minoan town dating to the Bronze Age (ca. 1800–1500 B.C.). Her pioneering work (1901–1904) both as an archaeologist and as a woman left an important legacy for future generations of researchers in that part of the world. Plate 7 shows Boyd, her assistant Edith Hall Dohan, and the entire staff of male workers that she directed at Gournia. The Museum's work in Crete continued with excavations between 1904 and 1915 by Dohan and Richard B. Seager at Vasiliki, Vrokastro, Pseira, and other sites. Recent research at Vrokastro and the surrounding region has been under the direction of Barbara J. Hayden.

In 1931 the Museum secured permission from the Italian government to excavate the ancient Roman and pre-Roman city of Minturnae, fifty miles from Naples. Situated along the Appian Way, the site featured a well-preserved aqueduct, several temples, a theater, and baths, as well as important collections of marble sculpture (Plate 29).

For over twenty years the Museum's focus on Classical sites was directed at Cyprus. B. H. Hill excavated the Bronze and Iron Age cemetery at Lapithos in 1931, and in 1934 started at Kourion, where several sites belonging to different periods, from Neolithic to Roman times, formed one extensive settlement. Excavations at Kourion were later directed by George H. McFadden, but ended with his death in 1953.

In 1950, Rodney S. Young began excavations at the ancient Phrygian capital of Gordion in central Turkey (Plate 47). The ancient city was occupied at various times from the Early Bronze Age into the medieval period, but it is particularly important for documenting the 1st millennium B.C. culture of the Phrygians, who flourished under their famous king, Midas, in the late 8th century B.C. In 1957, with the opening of the great tumulus, the expedition made one of the most spectacular archaeological discoveries of the 20th century. Though Young died in 1974, work at the site has continued under the direction first of Keith DeVries, and then of G. Kenneth Sams and Mary M. Voigt.

The Museum Applied Science Center for Archaeology (MASCA), established in 1961, has pioneered the archaeological application of methods and techniques from the physical and chemical sciences. Using electronic sensing devices as well as aerial photography, the Museum and the Lerici Foundation of Milan set out in 1961 to find the buried Greek city of Sybaris in southern Italy. By 1968, after locating the site buried below sea level, the actual excavation of the site was turned over to the Italian government.

The University of Pennsylvania Museum participated in a number of excavations at other Italian sites during the 1960s and 1970s, including Artena (Plate 60), Ciro, Gravina, and Ischia.

The discipline of underwater archaeology was developed by George F. Bass while working at the University of Pennsylvania Museum (Plate 58). In 1960 and 1961, just off Cape Gelidonya on the southwest coast of Turkey, Bass excavated one of the oldest shipwrecks ever found, a small Bronze Age merchant ship that sank sometime during the 14th or 13th century B.C. This was the first excavation to adapt the standards of land archaeology to underwater remains. Bass had to devise new tools and techniques for this work, including a two-person submarine for underwater mapping, built in 1964 by General Dynamics (Plate 59).

Begun in 1969 while he was at the University of Michigan, Donald White's excavations of the sanctuary of Demeter and Persephone at Cyrene, a Greek colony on the coast of Libya, were sponsored by the University of Pennsylvania Museum from 1973 to 1981. The sanctuary was destroyed by a massive earthquake in A.D. 262. White also excavated a Late Bronze Age seaport at Marsa Matruh on Bates' Island, off the northwest coast of Egypt (1985–89).

The Corinth Computer Project, directed by David G. Romano, has been involved in making a computerized architectural and topographical survey of Roman Corinth and the surrounding landscape (1988–2000).

Far East

Between 1896 and 1901, three University of Pennsylvania students—William Henry Furness III, Hiram M. Hiller, and Alfred C. Harrison, Jr.—made several extended trips to Borneo, India, and Japan, as well as to other parts of South and Southeast Asia, on behalf of the Museum. They collected articles of daily life and documented cultural practices of people who were little known to outsiders at the time. Exotic at first glance, the portraits of the Dayak warrior (Plate 4) and the Ainu woman (Plate 5) reflect universal human aspirations and experience.

In 1914–15 Henry Usher Hall made an ethnographic study along the Yenisei River in Siberia with anthropologist Marie A. Czaplicka of

Somerville College, Oxford. The expedition contacted a number of Siberian nomadic groups including the Samoyed, Tunga, Yurak, Dolgan, and Yakut tribes (Plate 9).

Carl W. Bishop, born in Tokyo to missionary parents, was Assistant Curator of the Museum's Section of Oriental Art from 1914 to 1918. He conducted two reconnaissances in China, Korea, and Japan to look for archaeological sites, but was unable to initiate a long-term research project because of the unstable political situation at the time. Paula L. W. Sabloff has been studying the rise of democracy in Mongolia since the early 1990s.

Carleton S. Coon was one of the last "generalist" anthropologists, proficient in archaeology, physical anthropology, and cultural anthropology. His main areas of study were human prehistory and race. He excavated Paleolithic remains in Afghanistan in 1954. In 1956–57 he took a trip to East and South Asia to document the cultural and physical diversity of human populations in these areas (Plates 50–52).

Mohenjo-daro, Pakistan, is the largest and best-preserved Harappan (2500–1500 B.C.) city in the Indus Valley. George F. Dales directed archaeological excavations in 1963–65 to reassess earlier work by the Indian Archaeological Survey (1920s to 1930s) and learn the reasons for the decline of Harappan civilization. Dales also surveyed the coast of Pakistan and the inhospitable Seistan region of southwestern Afghanistan in search for evidence of contact between the Indus and Mesopotamian civilizations (Plate 63).

The greatest recent discovery in Southeast Asia has been the evidence for a previously unknown Bronze Age culture in Thailand. The discovery of early metallurgy during the Museum's 1974–75 excavations at Ban Chiang, led by Chester Gorman, with subsequent analyses by Joyce C. White and colleagues, has revolutionized archaeologists' understanding of the development of cultural complexity in this part of the world.

Gregory L. Possehl's research has focused on the origin and development of urbanization in South Asia, specifically of the Harappan civilization that flourished in the region of the Indus River. He has excavated three sites in the state of Gujarat, India, including Rojdi (1982–93), which have helped redefine the chronology for the region and have given much insight into subsistence systems and the decline of Harappan civilization.

North America

Early Museum investigations into the human past were never confined to the Old World alone. Already in 1889 and on through the 1890s Charles C. Abbott and Henry C. Mercer, the first two curators of the American Section, were researching the antiquity of human occupation at

Abbott's Farm in Trenton, New Jersey. They excavated sites in Pennsylvania, New Jersey, Maine, and Tennessee. Frank Hamilton Cushing, the famous anthropologist who had become a high-ranking member of Zuni society, was hired in 1895–96 to excavate pre-Columbian remains at Key Marco in Florida.

North American ethnographic and linguistic research soon followed as well. George B. Gordon, who eventually became Museum Director (from 1910 to 1927) traveled to Alaska in 1905 and 1907 to photograph, study, and collect artifacts among Eskimo peoples. The great linguist Edward Sapir, one of the founders of the discipline, began his career at the Museum and in 1909 visited the Uintah reservation in Utah to study the language of the Utes.

Research conducted among various nations of northeastern North America between 1908 and 1950 by the indefatigable Frank G. Speck, founder of the Anthropology Department at the University of Pennsylvania, helped preserve vital information about many cultures of this area. He photographed, studied, and worked with the Penobscot in Maine, the Naskapi in Labrador, and the Iroquois in New York, as well as many others (Plates 35–38).

In 1912 the Museum appointed Louis Shotridge, a Tlingit from southeastern Alaska, Assistant Curator in the American Section. Shotridge took extended trips between 1915 and 1932 to collect artifacts and data among his own and neighboring people in Alaska and British Columbia (Plate 20).

William B. Van Valin collected ethnographic material among the North Alaska coast Iñupiaq and excavated ancient remains at Point Barrow, Alaska, 1917–19 (Plate 13). From 1930 to 1935 Frederica de Laguna conducted pioneering archaeological and ethnographic work in Alaska.

Another pioneer, Edgar B. Howard, explored for evidence of Paleolithic remains in North America. His excavations at Clovis, New Mexico, from 1933 to 1937 with John L. Cotter, a Penn graduate student, and in Eden Valley, Wyoming, 1940–41, established his reputation as one of the discoverers of the original inhabitants of the continent.

J. Alden Mason, Curator of the American Section from 1926 to 1955, undertook archaeological, ethnographic, and linguistic expeditions throughout North, Central, and South America. He is best known for his linguistic studies among indigenous people of northern Mexico, including the Tepehuan in 1948 (Plate 42).

Although principally affiliated with the University of Alaska and later Brown University, J. Louis Giddings worked on joint Museum expeditions to the north Bering Sea coast in Alaska, 1949–50, and to Onion Portage, also in Alaska, in the 1960s. These excavations produced long series of stratified cultural levels dating back to 4000 B.C.

With the arrival of John L. Cotter at the University of Pennsylvania in the 1960s, Historical Archaeology was established as an academic disci-

pline. The Museum helped sponsor a number of field projects in and around Philadelphia, including the First African Baptist Church and the Walnut Street Prison Workshop.

Robert L. Schuyler has continued the Museum's important work in American historical archaeology with digs at Silver Reef, an abandoned 19th century (ca. 1876–93) silver mining town in southwestern Utah (1981–96), and a new project centered in Vineland, New Jersey, aimed at uncovering the history of the region.

Robert W. Preucel currently conducts a collaborative project with the Pueblo of Cochiti, New Mexico, focusing on the ancestral Cochiti site (Kotyiti) inhabited subsequent to the Pueblo Revolt of 1680, while Marilyn Norcini is preparing a biography of the late Pueblo anthropologist Edward P. Dozier.

Mesoamerica

Robert Burkitt worked in the highlands of Guatemala for over twenty years (1913–34). His excavations at such ancient Maya sites as Chamá, Chocolá, and Ratinlixul provided the Museum with the only archaeologically documented collections from this area in the United States.

In 1930, using a twin-motor Sikorsky amphibian aircraft (Plate 22) flown by two Pan American pilots, Percy Madeira, Jr., and J. Alden Mason flew over 2,500 miles of land never before seen from the air (Plate 24). One of the first archaeological surveys by airplane, the expedition traversed portions of Yucatan, Mexico, and the Petén, Guatemala, in search of Maya sites.

The ancient city of Piedras Negras, deep in the jungle of the Petén, Guatemala, and known for its elaborately carved and well-preserved monuments, was the site of the Museum's first large-scale excavation of a Maya ruin. The work, directed by J. Alden Mason and Linton Satterthwaite, lasted from 1931 to 1939 (Plates 32 and 33).

Mason returned to Central America in 1940 to excavate in Panama at Sitio Conte. Following earlier work at the site conducted by Harvard University, Mason uncovered a large number of burials bearing beautiful painted pottery and outstanding gold ornaments. Linton Satterthwaite excavated at Caracol and other sites in Belize between 1950 and 1953, continuing his interest in Maya calendrics and architecture.

Due to its inaccessible location in the jungles of the Petén, Guatemala, the ancient Maya city of Tikal was only briefly visited by explorers until the Museum organized a large-scale project of excavation and restoration with the assistance of the Guatemalan government. Beginning in 1956, under the successive leadership of Edwin Shook, Robert H. Dyson, Jr., and William R. Coe, archaeological investigations cleared many of the important buildings and revealed the dynastic,

architectural, and settlement history of one of the most important Maya cities (Plates 48 and 49).

For a number of years (1950s–70s) Ruben E. Reina traveled widely among the contemporary Maya living in the highlands of Guatemala. He produced seminal studies on their social organization and the relationship of technology and culture, specifically the production of pottery (Plates 55 and 56). He also directed two archaeological projects in Guatemala and made an ethnohistorical study of the Archives of the Indies in Spain to develop a comprehensive view of the Maya people during the time of the Spanish Conquest.

Additional important work on the ancient Maya was conducted by William R. Coe, Christopher Jones, and Robert J. Sharer at Quiriguá, Guatemala (1974–79), and recently (1988–2000) by Sharer at Copán, Honduras, where the project has traced the architectural history of the Copán Acropolis by tunneling into the early buildings.

South America

Max Uhle, a German philologist and archaeologist, explored Bolivia and Peru between 1895 and 1897 (Plate 3). By uncovering the various levels of Inca and pre-Inca occupation at the ancient religious center of Pachacamac in Peru, he established the initial understanding of the cultural history of the Andean region of South America.

The great explorer William C. Farabee spent three years (1913–16) traveling up and down the Amazon River and its tributaries to identify and study the vast diversity of indigenous people found in this area of the world. The unusual attire of the Yahua family (Plate 16) and the Waiwai chief (Plate 12) or the near-nakedness of the Mapidian chief (Plate 10) may easily evoke impressions of savagery or simplicity. Viewers need to question assumptions of cultural superiority and reflect upon how we often judge others based on superficial characteristics such as appearance. Conversely, the photograph of the Mapidian hunter (Plate 11) might seem to represent the idyllic view of humans at one with nature, the native unsullied by modern civilization. This frozen moment allows the viewer to forget that amidst the beauty there is a constant struggle to survive, wherever one may live. Farabee returned to South America in 1922–23 to locate and excavate ancient sites in southern Peru.

The Macoa Indians living in the mountains of the Sierra de Perija between Venezuela and Colombia were first visited by an anthropologist during a reconnaissance by Theodoor de Booy in 1918 (Plates 15 and 17).

The Italian-born anthropologist Vincenzo Petrullo started a new program of ethnographic research in South America with the expedition to Mato Grosso, Brazil, in 1931, followed by two projects in Venezuela in 1933 and 1934–35. Establishing headquarters at the headwaters of the Paraguay

River (Plate 30), Petrullo studied the Bororo (Plate 31) and then traveled north to the unexplored area around the tributaries of the Xingu River where he made contact with people who had never before met Westerners.

Kenneth Kensinger was a doctoral candidate in Anthropology at the University of Pennsylvania when he visited the Cashinahua in the jungles of southeastern Peru (Plate 55). He had previously conducted linguistic research with the same people, which included the development of a phonetic system for writing their language.

Current work in South America is being carried out by Clark L. Erickson. His fieldwork in the Bolivian Amazon involves archaeological survey, mapping, and excavation of raised fields and other traditional agricultural systems, as well as a program aimed at reviving this technology.

Africa

In addition to its extensive work in Egypt, Nubia, and North Africa, the University of Pennsylvania Museum has sent several expeditions to sub-Sarahan Africa as well.

Henry U. Hall came out of retirement to lead the West African Expedition in 1936–37. He spent seven months studying the Sherbro of the southeastern coastal region of Sierra Leone, specifically in the two Chiefdoms of Sherbro Island and in the mainland Chiefdom of Shenge (Plates 39–41). Plate 41 impresses the viewer with the exotic imagery that so often accompanies such work.

Carleton Coon excavated Neolithic remains in a cave at Yengema, Sierra Leone (1966). A reconnaissance of Cameroon, a virtually unknown archaeological area at the time, was carried out by Nicholas David in 1967. Also in 1967, Robert Netting made an ethnographic study of the Kofyar in northern Nigeria.

Recently Kathleen Ryan of the Museum Applied Science Center for Archaeology has worked with the Masai in Kenya to document cattle-herding practices in order to gain insights into ancient subsistence practices. She has also made a study of native medicine.

Oceania

In addition to the early (1896–98) explorations in Borneo by Furness, Harrison, and Hiller mentioned above, the Museum sponsored D. S. Davidson's ethnographic and archaeological research in northwest Australia, 1930–31. However, most of the Museum's work in Australia and the islands of the Pacific was carried out after World War II.

New Guinea is ethnologically one of the most varied and interesting

places in the world. In 1951 it was also one of the least known. Ward H. Goodenough spent three months surveying New Guinea and its adjacent islands to select an area for possible in-depth research. He returned in 1954 to study the Nakanai, who lived on the island of New Britain (Plate 44).

The Tiwi are an Australian Aboriginal group living on Melville Island. Jane Goodale, then a graduate student in the Anthropology Department of the University of Pennsylvania, spent most of 1954 living among them and studying their customs (Plates 45 and 46).

Ward Goodenough spent ten months in 1964–65 in Truk, in the Caroline Islands, Micronesia. He studied material culture and the native language, eventually producing a *Trukese-English Dictionary* (1980). William H. Davenport worked in the Solomon Islands, Melanesia, studying social change, archaeology, and ethnography (1964–66).

Europe

In addition to the archaeology of Classical sites in the Mediterranean, the Museum has also carried out investigations of prehistoric and ancient humans at a variety of sites in northern and eastern Europe. Henry C. Mercer conducted a survey of Paleolithic sites in France and Spain, 1892–93, and Henry U. Hall worked in France in 1923, as did Virginia Beggs in 1937 and 1939.

Vladimir Fewkes served as Field Director for four seasons (1929–32) on the first American archaeological expedition to Central Europe, under the joint auspices of the University of Pennsylvania Museum and the Peabody Museum of Harvard University. He excavated a number of sites in what is now the Czech Republic ranging in date from the Early Neolithic to the Iron Age. This work was followed by Eugene Golomshtok's excavations at Esske-Kermen in the Crimea in 1933.

More recently, Bernard Wailes, a specialist in late European prehistory and the early Medieval period, directed the excavations at Dún Ailinne, County Kildare (1968–75), as well as other prehistoric and historic sites in Ireland and England. Harold L. Dibble and Philip G. Chase have excavated at several important Paleolithic sites in France, including La Quina (1984–88), Combe-Capelle (1987–90), and Fontéchevade (1994–98).

Photography and Anthropology

One of the most powerful forms of media to convey information about and advance understanding of foreign people and places is photography. Photographs offer a kind of documentation not found in artists' renderings

or the written word. The accuracy of photography in portraying the likeness of individuals or natural and architectural landscapes is astonishing, though today perhaps taken mostly for granted.

The power of photographs resides also in the "frozen" quality of each image. The photographic print, like the written word, can be experienced in quiet contemplation and will reveal itself in different ways, depending on the viewer and the context of the experience. Each image is a moment in time and place that may be observed again and again.

Early anthropological photography was not carried out by anthropologists. Photographs of distant lands were taken by soldiers, missionaries, merchants, and other travelers (see Plates 5 and 12). There was a ready market for images of forgotten ruins, Biblical landscapes, or exotic-looking people. Old myths were revived and imagined places became real. Today many of these photographs provide a wealth of documentation for anthropologists and historians of the discipline. But the perhaps unconscious motives of the photographer must be noted as well: by stressing the primitive aspects of indigenous people around the world, photographs were sometimes also used to justify the imperial ends of colonial powers. It was in reaction to this at best untrained use of photographic documentation that professional anthropologists, including researchers at the University of Pennsylvania Museum, began to collect their own field data and photographs systematically.

Field photography was extremely difficult in the years just after the invention of the medium in the first half of the 19th century. Glass plate negatives were cumbersome and fragile and needed to be prepared, exposed, and developed in rapid succession with an array of perishable chemicals—all while still in the field. Photographic equipment was heavy and expensive, and photographers needed to transport a complete darkroom on their travels. When the University of Pennsylvania Museum began its research programs in the late 1880s, some of these obstacles had been overcome by the constant evolution of the technology. Even so, the process required rigorous training.

The anthropologists and archaeologists working for the Museum were usually not professional photographers and often obtained mediocre results by artistic standards. But the anthropologist in the field has always sought scientific accuracy, not necessarily quality of composition or aesthetics of subject matter. In fact, the aim has been to remain free of any artifice that may obscure the realism of the image (Plates 4 and 55, in contrast to Plate 27). Art, which implies subjectivity, is often avoided. Through photographs the anthropologist has sought to portray people in the context of their social and physical environment (Plate 15).

By witnessing and describing other ways of life, past and present, the anthropologist may also learn more about his or her own culture. Today, more than ever before, it is important to develop an increased awareness,

understanding, and respect for cultural differences.

Selected from thousands of expedition photographs in the Archives of the University of Pennsylvania Museum and representing a chronicle of the institution, these images allow the viewer to reflect on human history and diversity. The portraits of individuals, even when posed, speak to each of us differently. Even the ruins speak to us, telling stories of the activities of people who are now gone. We learn of the transience of people on earth and their inter-relatedness. We learn about cultural persistence and survival. We learn humility from seeing past greatness swept away by the passage of time.

Suggested Readings

Collier, John, Jr., and Malcolm Collier
 1986 *Visual Anthropology: Photography as a Research Method.*
 Albuquerque: University of New Mexico Press.

Edwards, Elizabeth, ed.
 1992 *Anthropology and Photography, 1860–1920.* New Haven, CT:
 Yale University Press.

Kuklick, Bruce
 1996 *Puritans in Babylon: The Ancient Near East and American
 Intellectual Life, 1880–1930.* Princeton: Princeton University Press.

Madeira, Percy C., Jr.
 1964 *Men in Search of Man: Seventy-Five Years of the University
 Museum of the University of Pennsylvania.* Philadelphia: University of
 Pennsylvania Press.

Rainey, Froelich
 1992 *Reflections of a Digger: Fifty Years of World Archaeology.*
 Philadelphia: The University Museum.

Rosenblum, Naomi
 1984 *A World History of Photography.* New York: Abbeville Press.

Winegrad, Dilys Pegler
 1993 *Through Time, Across Continents: A Hundred Years of
 Archaeology and Anthropology at The University Museum.*
 Philadelphia: The University Museum.

Acknowledgments

I would like to thank Jeremy A. Sabloff, the Williams Director, and Gerald Margolis, Deputy Director for Operations, without whom this project would not have been possible. Additional thanks are due to Walda Metcalf, Assistant Director for Publications; Jennifer Quick, Senior Editor; Harold Dibble, Deputy Director for Curatorial Affairs; Gillian Wakely, Associate Director for Programs; Suzanne Sheehan Becker, Director for Development; Kevin Lamp, Assistant Exhibits Designer; Jack Murray, Exhibits Designer; Charles Kline, Photographic Archivist; Francine Sarin, Photographer; Jennifer Chiappardi, Assistant Photographer; Aryon Hoselton; Sharon Misdea; and Mary Virginia Harris.

Index

Map of Museum Sites

Illustrated in the Plates

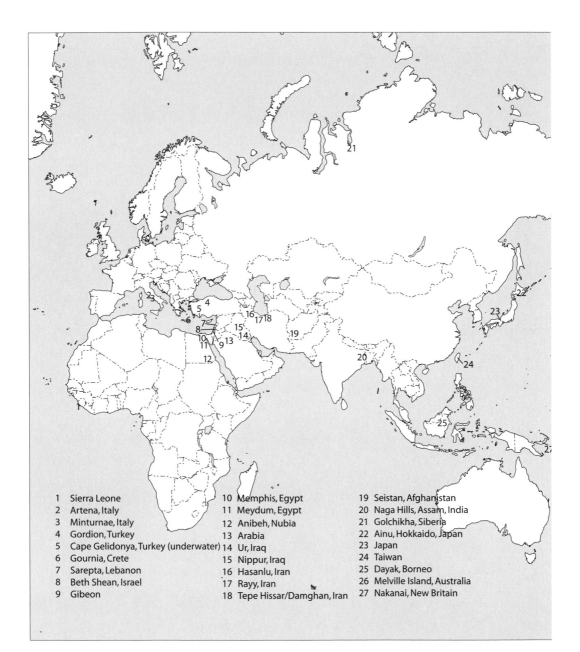

1	Sierra Leone	10 Memphis, Egypt	19 Seistan, Afghanistan
2	Artena, Italy	11 Meydum, Egypt	20 Naga Hills, Assam, India
3	Minturnae, Italy	12 Anibeh, Nubia	21 Golchikha, Siberia
4	Gordion, Turkey	13 Arabia	22 Ainu, Hokkaido, Japan
5	Cape Gelidonya, Turkey (underwater)	14 Ur, Iraq	23 Japan
6	Gournia, Crete	15 Nippur, Iraq	24 Taiwan
7	Sarepta, Lebanon	16 Hasanlu, Iran	25 Dayak, Borneo
8	Beth Shean, Israel	17 Rayy, Iran	26 Melville Island, Australia
9	Gibeon	18 Tepe Hissar/Damghan, Iran	27 Nakanai, New Britain

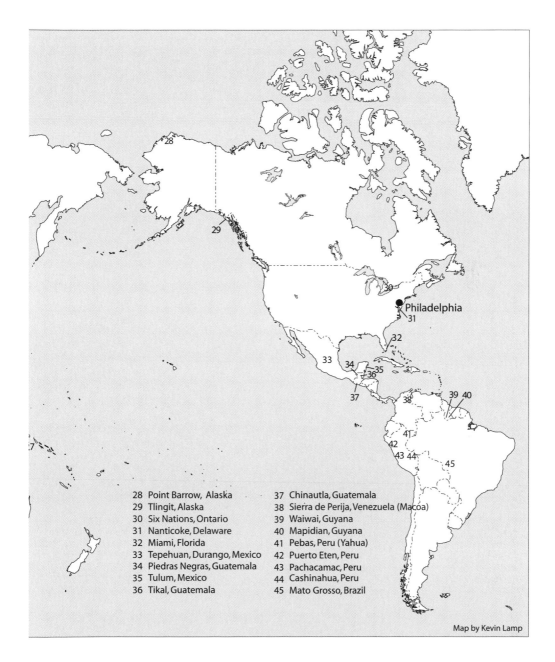

Philadelphia

28 Point Barrow, Alaska
29 Tlingit, Alaska
30 Six Nations, Ontario
31 Nanticoke, Delaware
32 Miami, Florida
33 Tepehuan, Durango, Mexico
34 Piedras Negras, Guatemala
35 Tulum, Mexico
36 Tikal, Guatemala

37 Chinautla, Guatemala
38 Sierra de Perija, Venezuela (Macoa)
39 Waiwai, Guyana
40 Mapidian, Guyana
41 Pebas, Peru (Yahua)
42 Puerto Eten, Peru
43 Pachacamac, Peru
44 Cashinahua, Peru
45 Mato Grosso, Brazil

Map by Kevin Lamp

Adventures in Photography

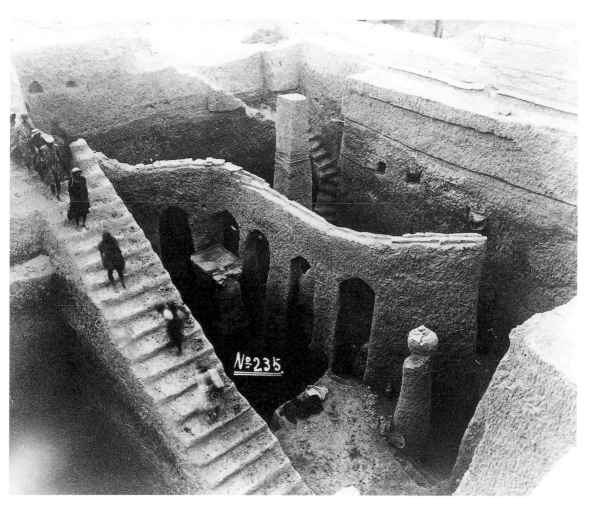

PLATE 1
Nippur, Iraq, 1895. Watercourse revealed by excavations. Workers carry away baskets of dirt.
Photograph by John Henry Haynes (neg. S4-143996)

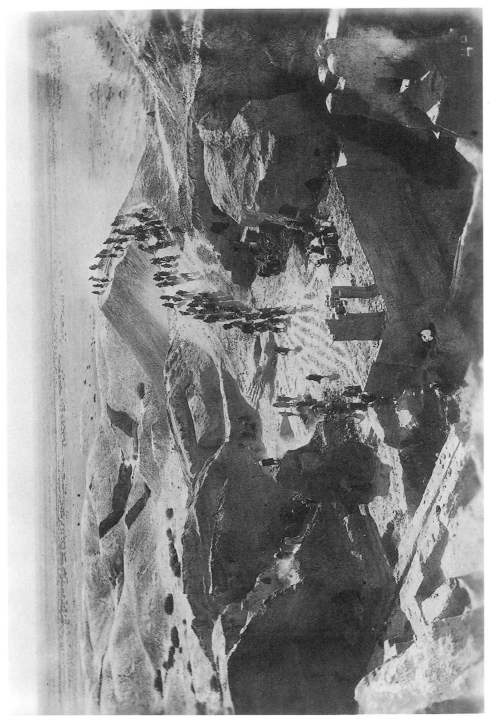

PLATE 2
Nippur, Iraq, 1899. View of excavations as seen from the top of the Ziggurat, the central temple of the ancient Sumerian city.
Photograph by John Henry Haynes (neg. S8-139049)

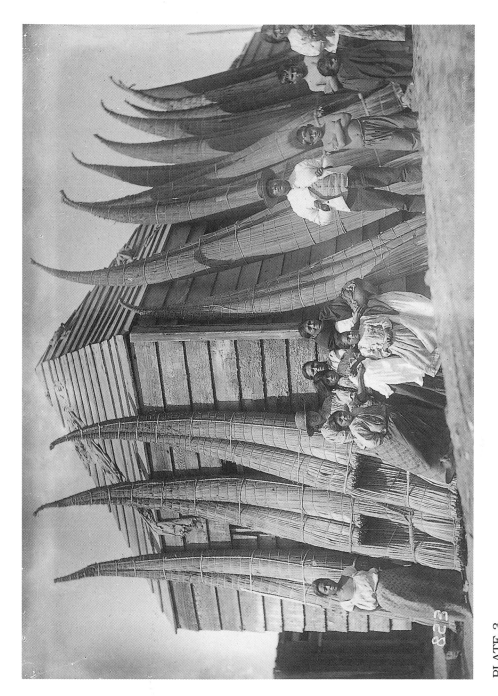

PLATE 3
Puerto Eten, Peru, 1897. Family of fishermen with reed boats.
Photograph by Max Uhle (neg. S4-139895)

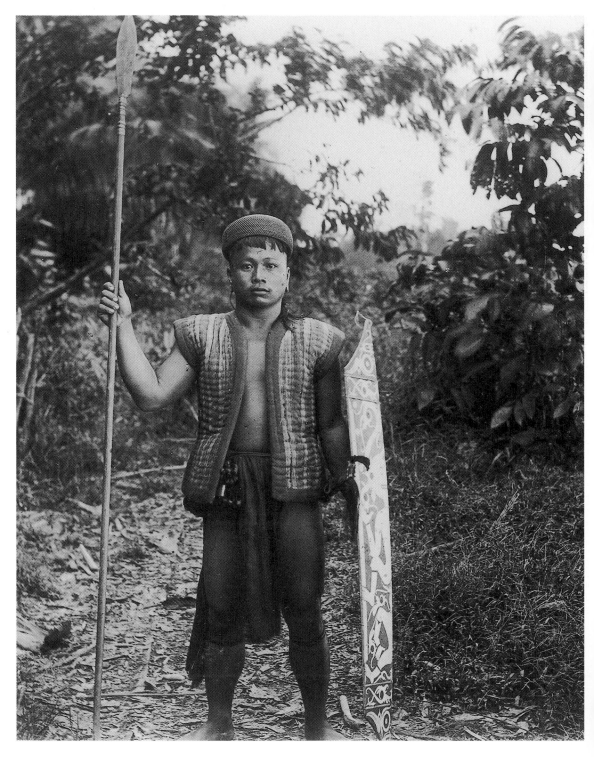

PLATE 4
Borneo, 1896–97. Tegang, a Dayak from Borneo was the guide of William Henry Furness III,
Alfred C. Harrison, Jr., and Hiram M. Hiller on their trip to the interior of the island.
Photograph by Alfred C. Harrison, Jr. (neg. S4-144004)

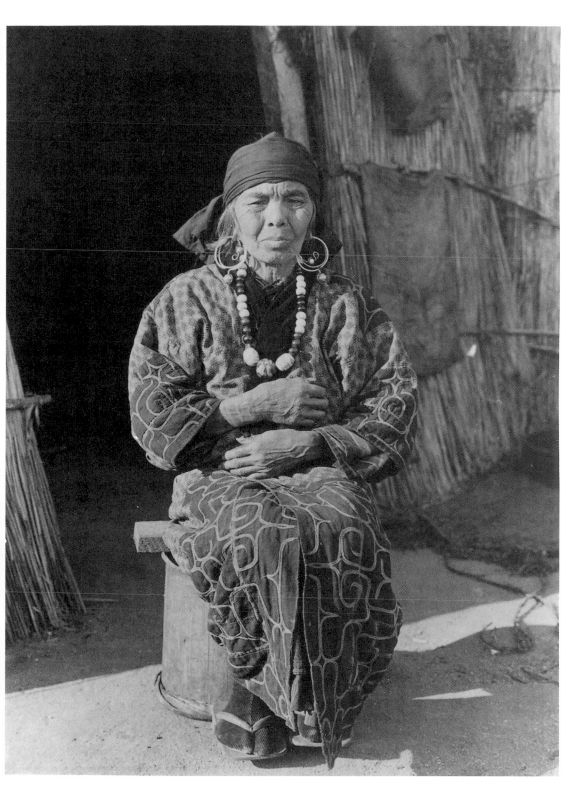

PLATE 5
Hokkaido, Japan, ca. 1901. Ainu woman.
(neg. S4-141965)

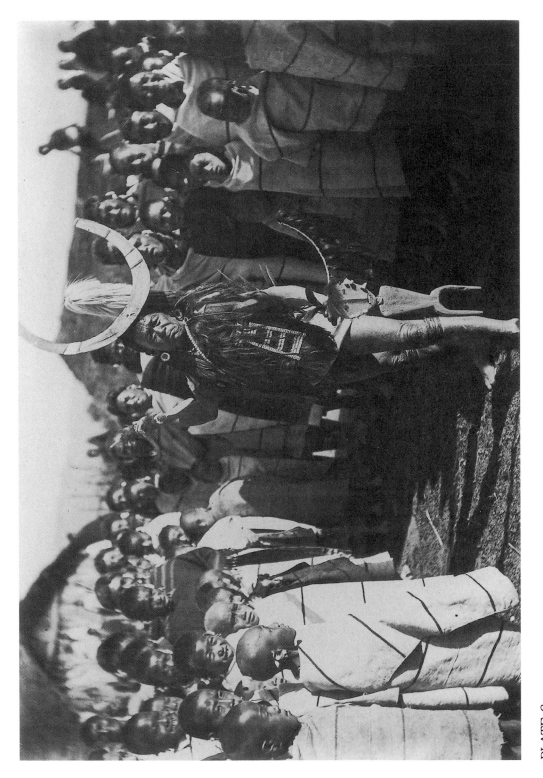

PLATE 6
Naga Hills, Assam, India, 1899. Angami Naga dancer performing in a ceremony.
(neg. S4-143993)

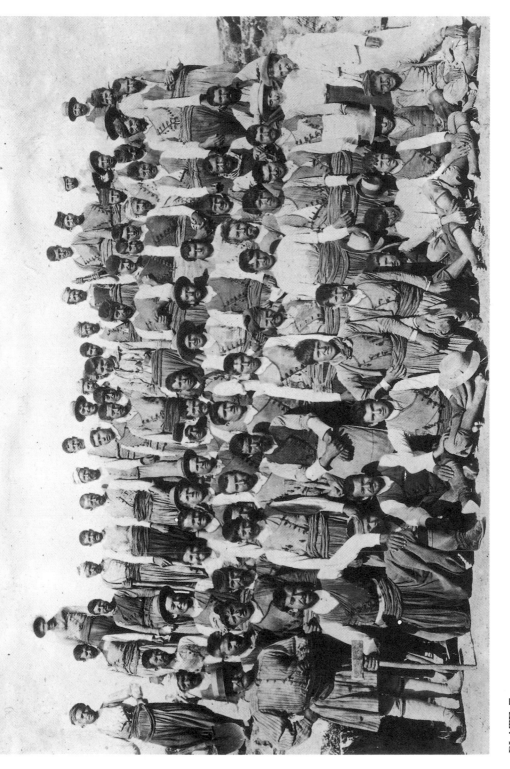

PLATE 7

Gournia, Crete, 1904. Workmen at Gournia. Harriet Boyd (Hawes), the first woman to excavate in Crete, stands at the far right with Edith Hall (Dohan) to her left. Note the traditional clothes worn by the workmen. (neg. S4-102168)

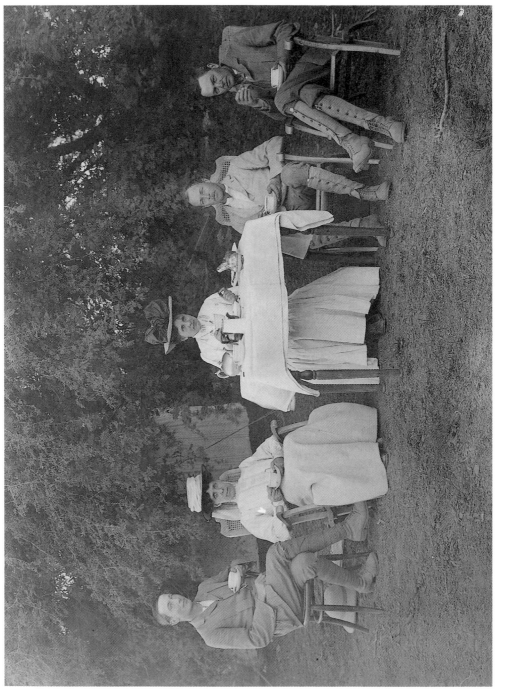

PLATE 8
Anibeh, Nubia, 1908. David Randall-MacIver and C. Leonard Woolley (at extreme right) take tea with visitors in full Edwardian dress.
(neg. S4-140721)

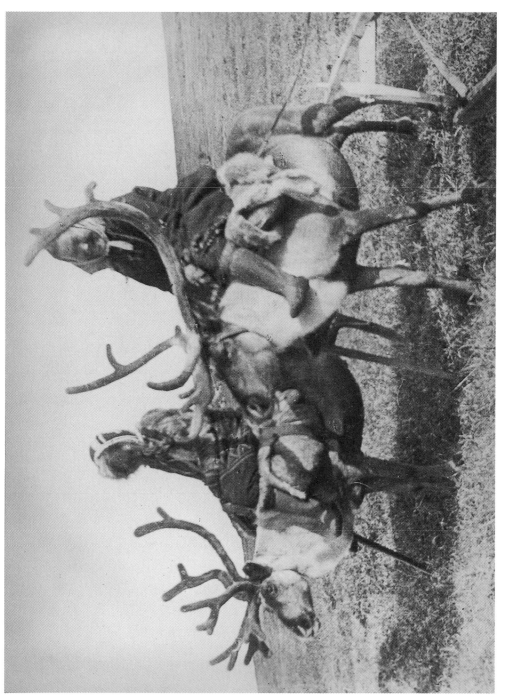

PLATE 9
Golchikha, Yenisey River, Siberia, 1914-15. Dolgan women riding reindeer.
Photograph by Henry U. Hall (neg. G5-25297)

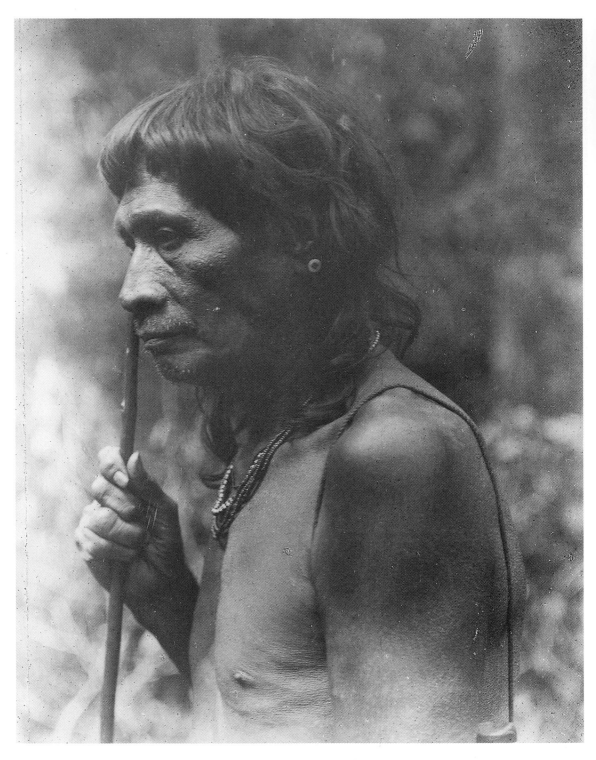

PLATE 10
Guyana/Brazil, 1914. Mapidian chief.
Photograph by William C. Farabee (neg. 28178)

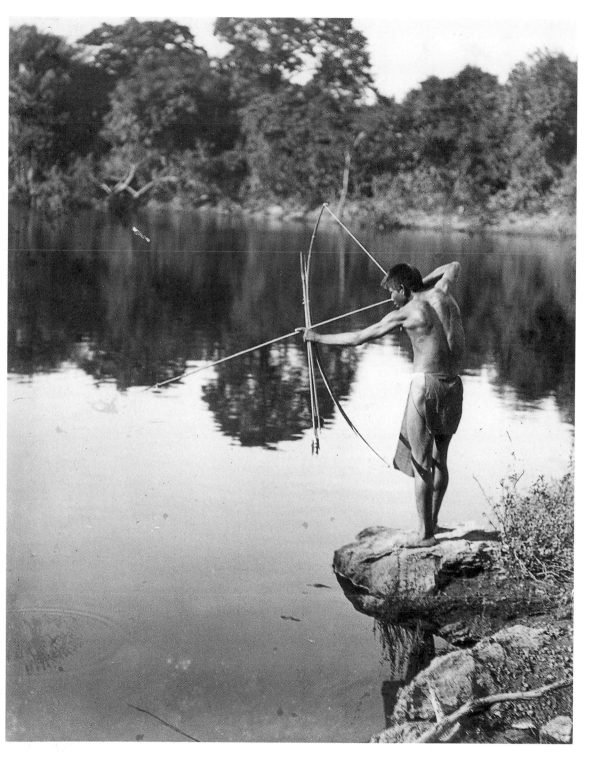

PLATE 11
Guyana/Brazil, 1914. Mapidian man shooting fish with bow and arrow.
Photograph by William C. Farabee (neg. 20744)

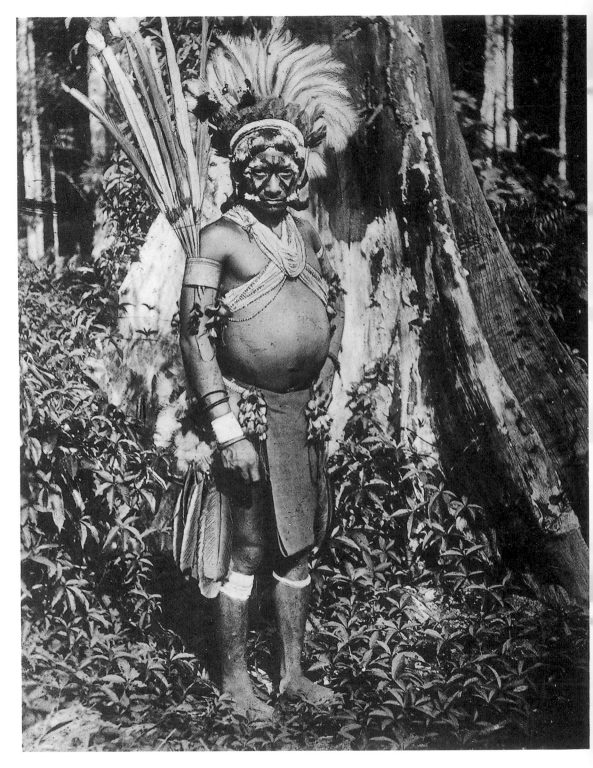

PLATE 12
Guyana/Brazil, 1910. Waiwai dance leader.
Photograph by John Ogilvie (neg. G8-41284)

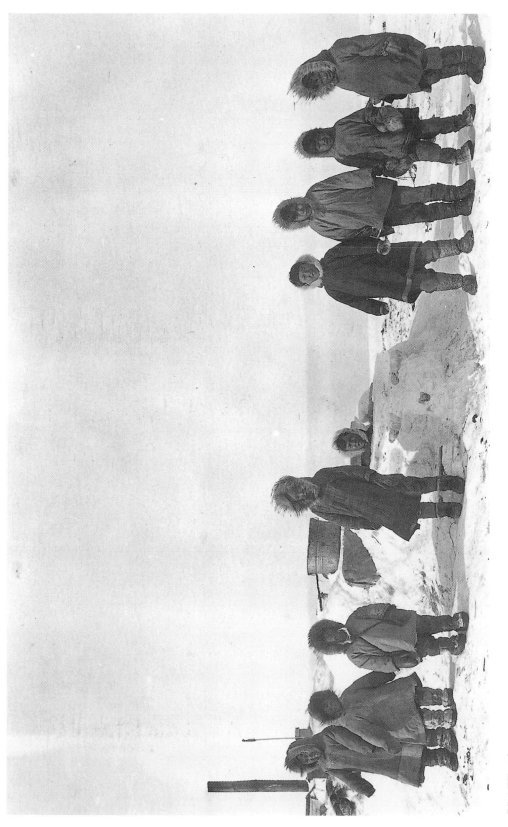

PLATE 13
Point Barrow, Alaska, 1917–19. Eskimo children playing in the snow in temperatures of 50 degrees below zero. Point Barrow is the northernmost location of mainland North America.
Photograph by William B. Van Valin (neg. S4-11328)

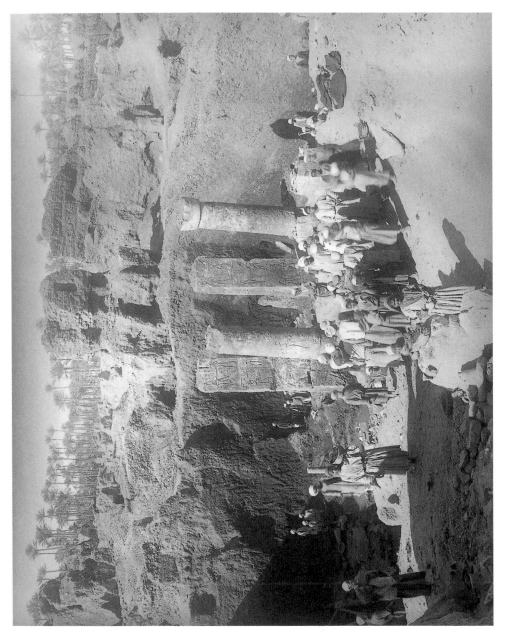

PLATE 14

Memphis, Egypt, 1915. General view of the Palace of the pharaoh Merneptah (ca. 1236–1223 B.C.) show-
ing progress of the excavations. The inscribed and painted columns are now in the University of
Pennsylvania Museum.

Photograph by Bechari (neg. G6-33944)

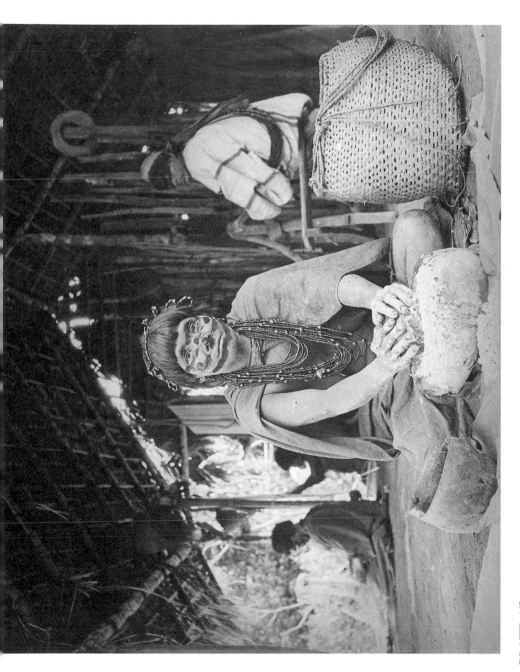

PLATE 15
Sierra de Perija, Venezuela, 1918. Macoa woman grinding cornmeal to make chicha, a native alcoholic drink.
Photograph by Theodoor de Booy (neg. 42545)

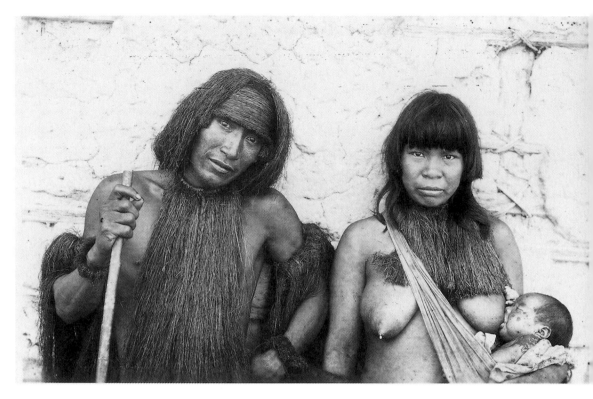

PLATE 16
Pebas, Peru, 1914. Yahua family. Note clothing made of grass.
Photograph by William C. Farabee (neg. 17900)

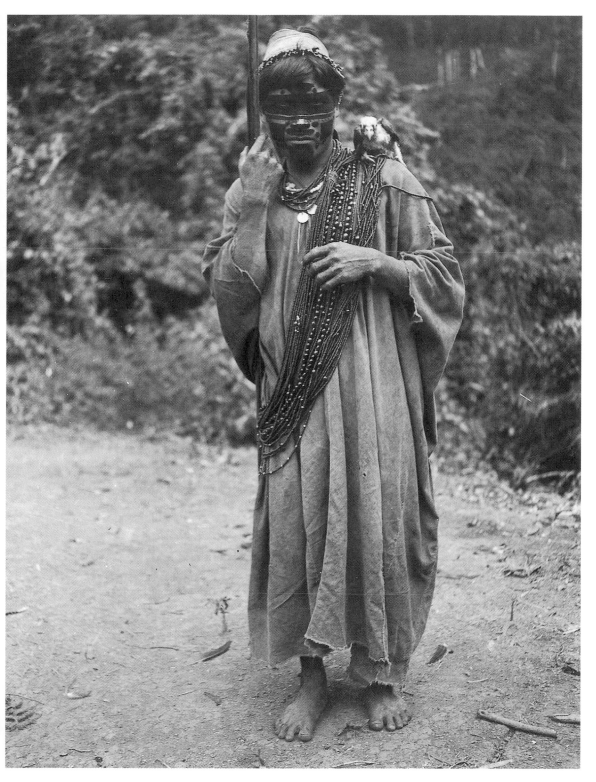

PLATE 17
Sierra de Perija, Venezuela, 1918. Macoa chief's brother with his tame parrot.
Photograph by Theodoor de Booy (neg. 27239)

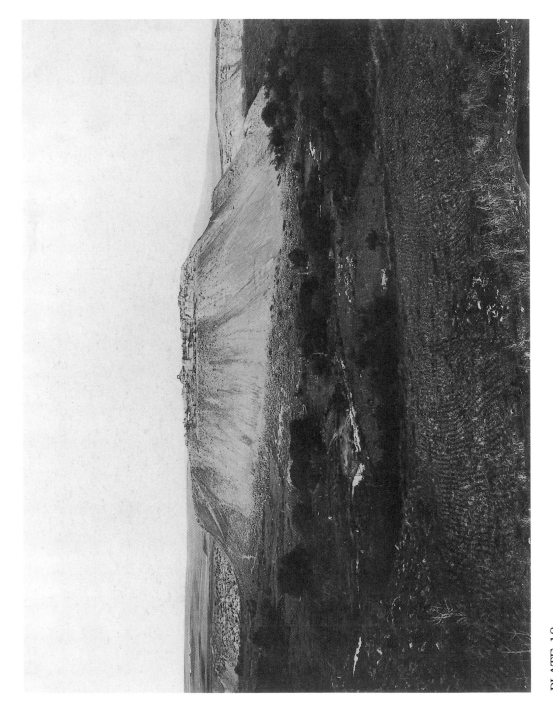

PLATE 18

Beth Shean, Israel, 1928. General view of the site as excavated at end of the 1928 season. Note figure on top of the mound for scale.

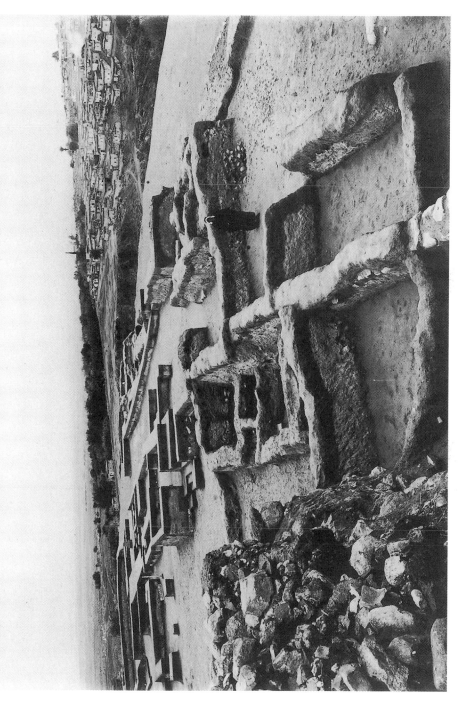

PLATE 19

Beth Shean, Israel, 1928. Southern area of the ancient city. The Canaanite temple of Mekal is in the background, and the modern town is at right in the distance. Photograph by Fadil Saba (neg. S4-144001)

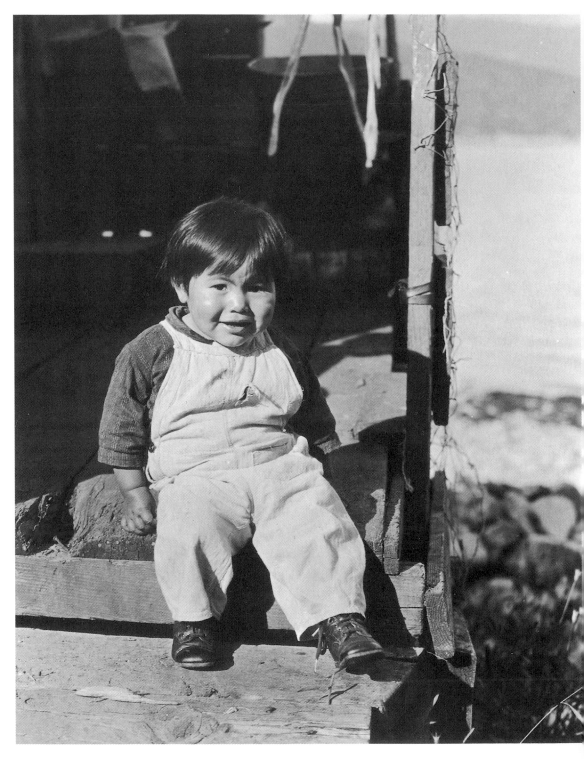

PLATE 20
Chilcoot, Alaska, 1917–23. A young Tlingit boy. Shotridge, for twenty years an anthropologist at the Museum, was himself a Tlingit.
Photograph by Louis Shotridge (neg. S5-15164)

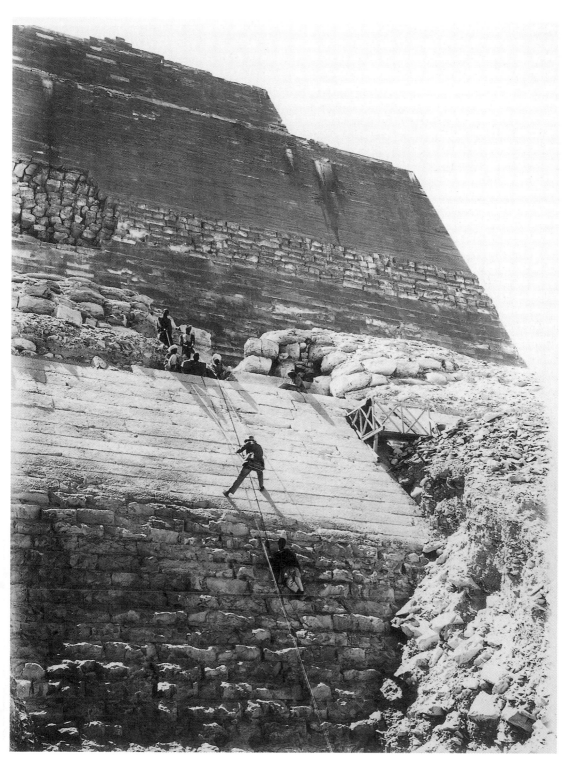

PLATE 21

Meydum, Egypt, 1930. Paul Beidler and Ahmed Abd el-Aziz measuring the stones on the north face of the Meydum Pyramid.

Photograph by Fadil Saba (neg. 134543)

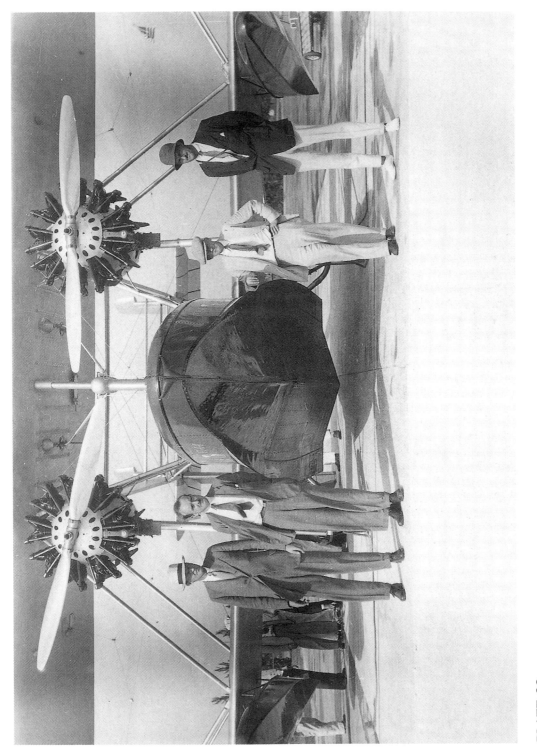

PLATE 22

Miami, Florida, 1930. Expedition staff in front of the twin-motor Sikorsky amphibian aircraft employed by the survey. From left to right are Percy C. Madeira, Jr., Robert A. Smith, J. Alden Mason, and Gregory Mason. Photograph by Fairchild Aerial Surveys, Inc. (neg. 7180)

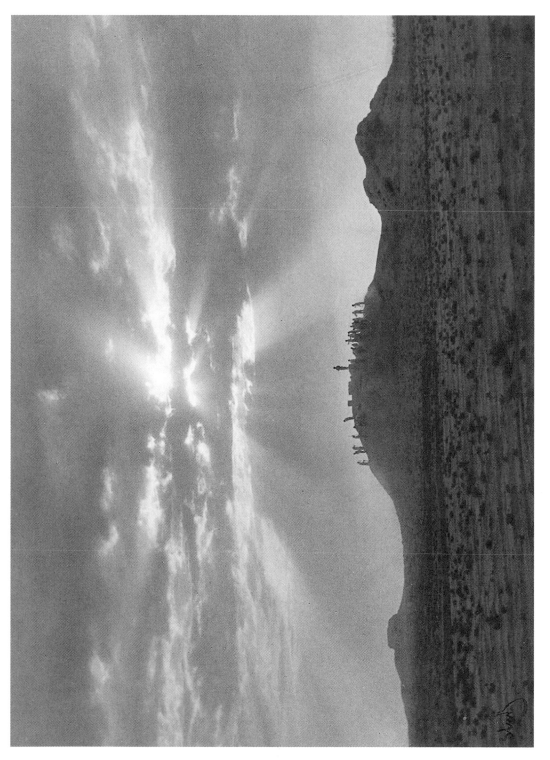

PLATE 23
Tepe Hissar, Iran, 1931. Autumn sun over the ancient site.
Photograph by Stanislaw Niedzwiecki (neg. S4-143995)

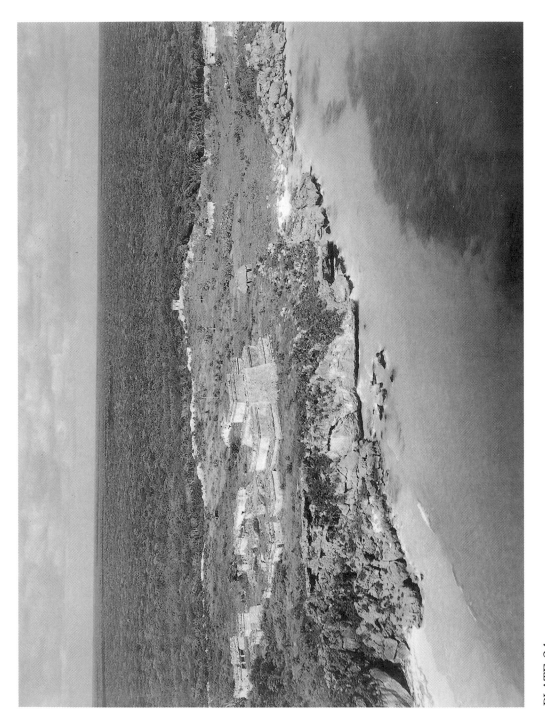

PLATE 24
Tulum, Yucatan, Mexico, 1930. Ruins of the ancient Maya city of Tulum on the east coast of Yucatan, as seen from the air.
Photograph by Fairchild Aerial Surveys, Inc. (neg. 6989)

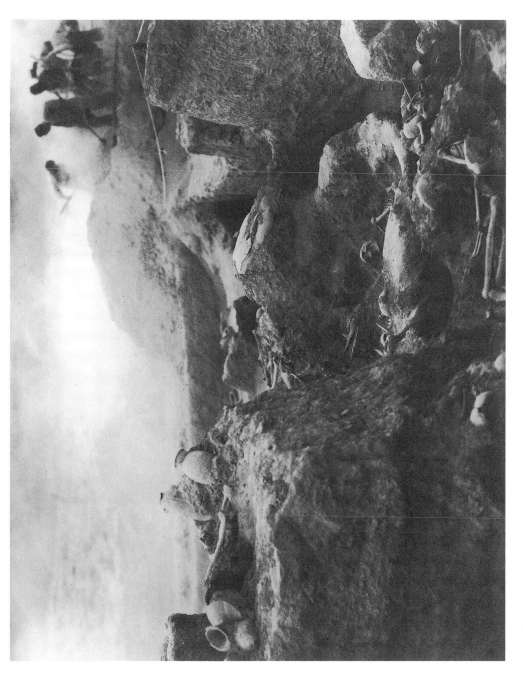

PLATE 25
Tepe Hissar, Iran, 1931–32. A view of the excavations. Ancient remains litter the foreground, while work continues in the background.
Photograph by Stanislaw Niedzwiecki (neg. S4-144007)

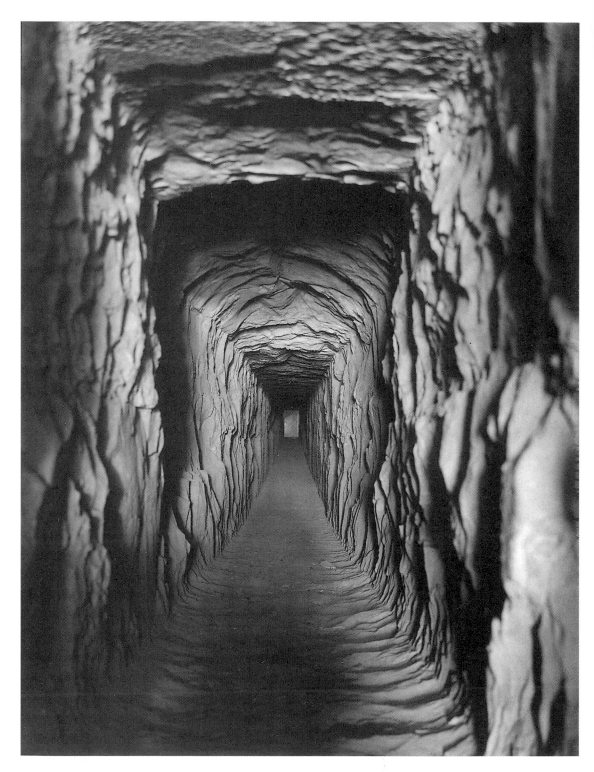

PLATE 26
Meydum, Egypt, 1930. Looking into the Meydum Pyramid from the main entrance, down a sloping passageway.
Photograph by Fadil Saba (neg. 34389)

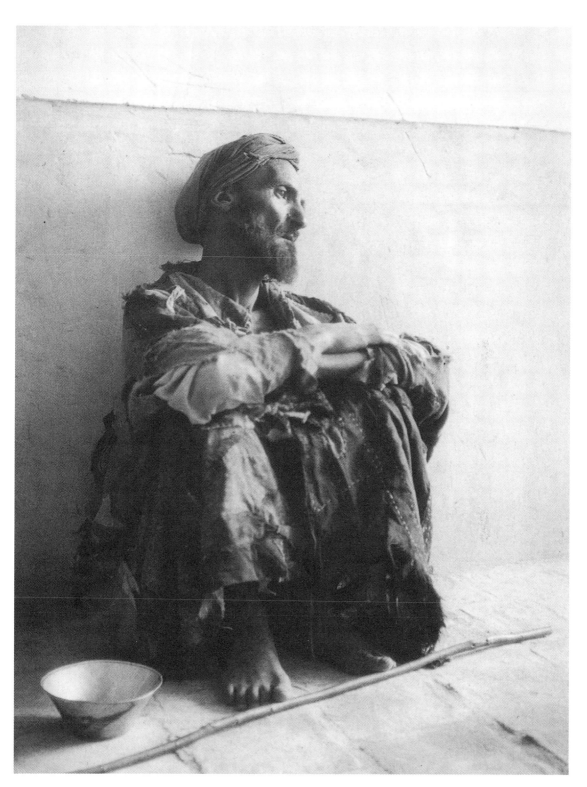

PLATE 27
Damghan, Iran, 1932. Seid, sitting against a wall, with his begging bowl and staff.
Photograph by Stanislaw Niedzwiecki (neg. 83368)

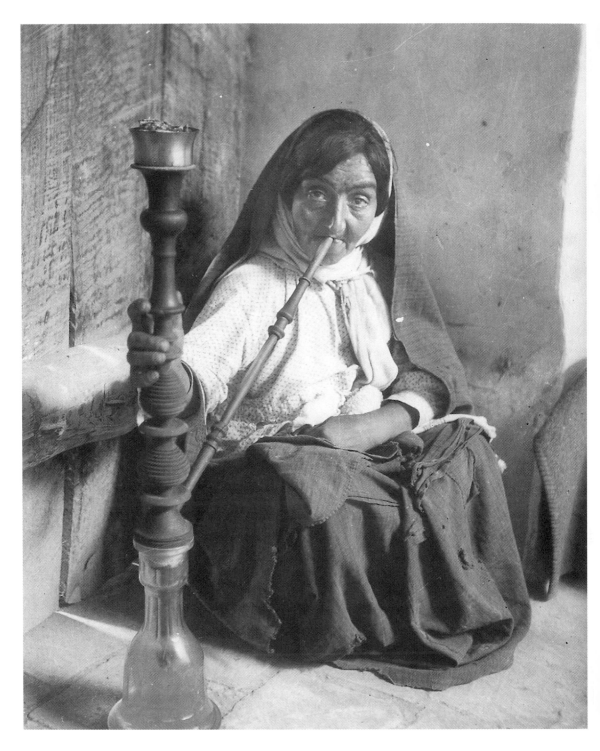

PLATE 28
Damghan, Iran, 1932. Woman smoking a water pipe.
Photograph by Stanislaw Niedzwiecki (neg. 83371)

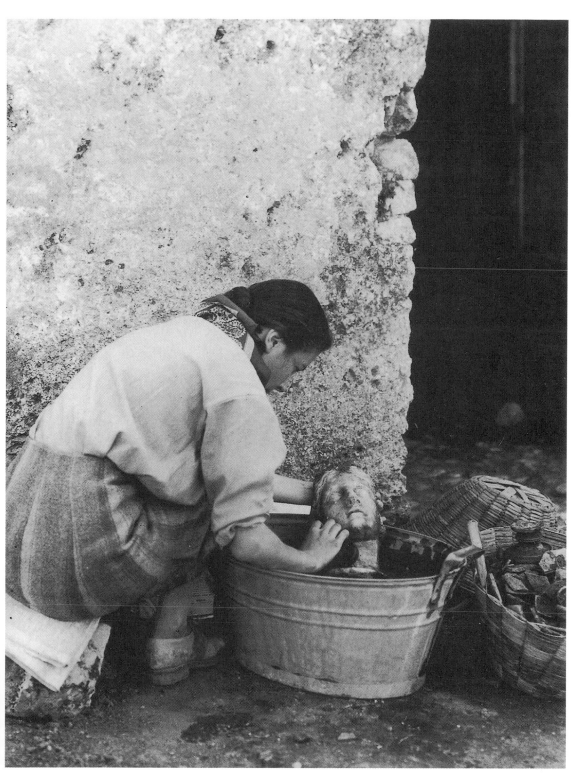

PLATE 29
Minturnae, Italy, 1931–1933. Agnes K. Lake washing the marble head of a Roman female statue found in the theater.
Photograph by Jotham Johnson (neg. S4-144003)

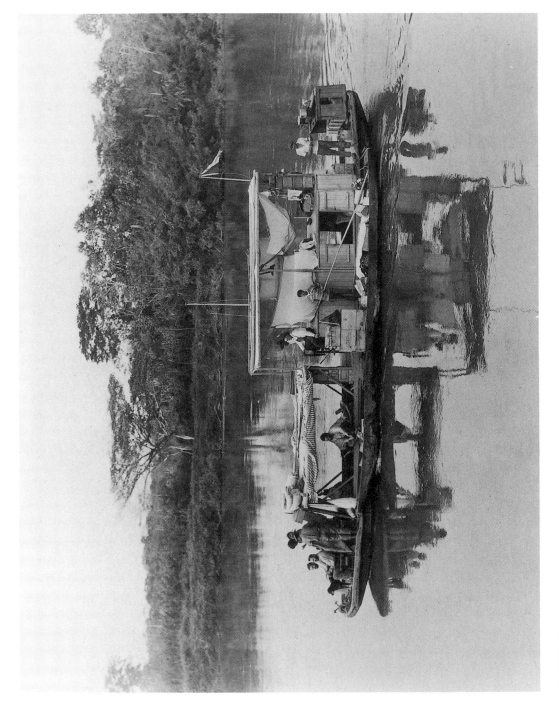

PLATE 30
Mato Grosso, Brazil, 1931. Expedition boat on the Paraguay River.
Photograph by Floyd Crosby [neg. S4-143971]

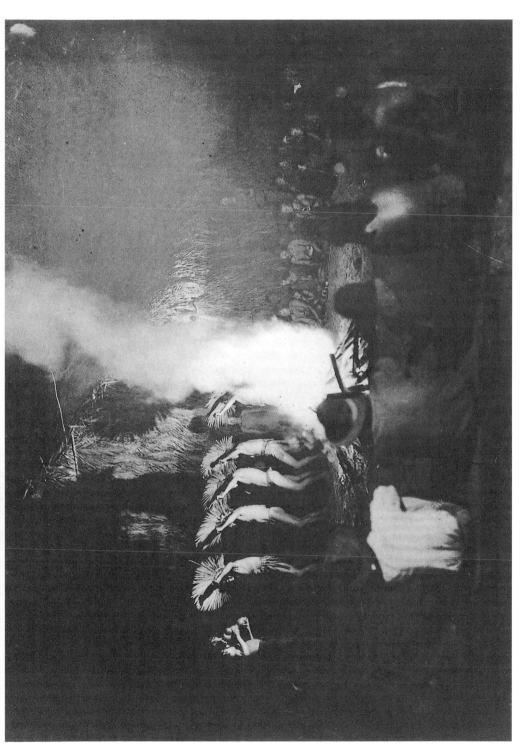

PLATE 31
Mato Grosso, Brazil, 1931. Bororo dance by firelight.
Photograph by Floyd Crosby (neg. S4-143994)

PLATE 32
Piedras Negras, Guatemala, 1931. Workers moving Altar 1. The city is known for its finely carved ancient Maya monuments and inscriptions.

PLATE 33
Piedras Negras, Guatemala, 1934. Building P-7, the best-preserved structure at Piedras Negras. Note the tree growing out of the roof.
Photograph by Linton Satterthwaite (neg. 16621)

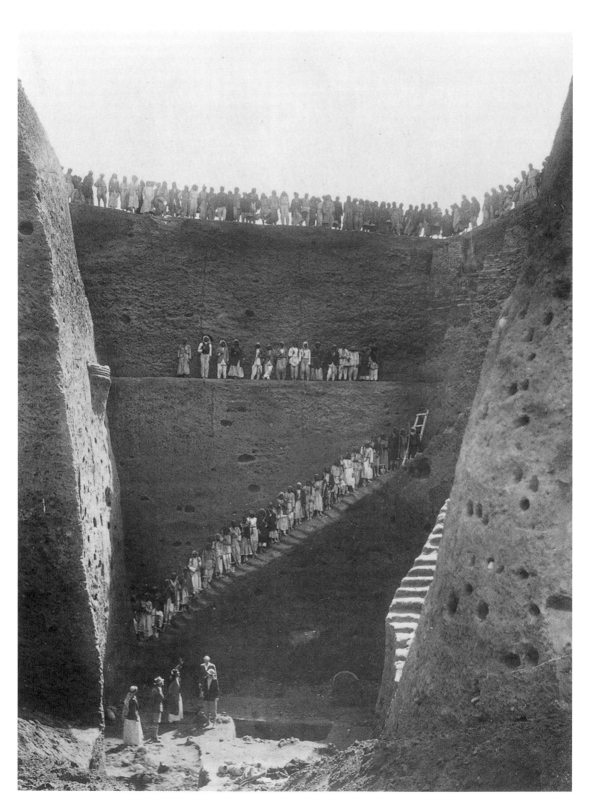

PLATE 34
Ur, Iraq, 1933–34. Excavation crew arrayed in Pit X, created through the removal of more than 13,000 cubic meters of soil.
Photograph by Yahia el Hamoudi (neg. S4-141589)

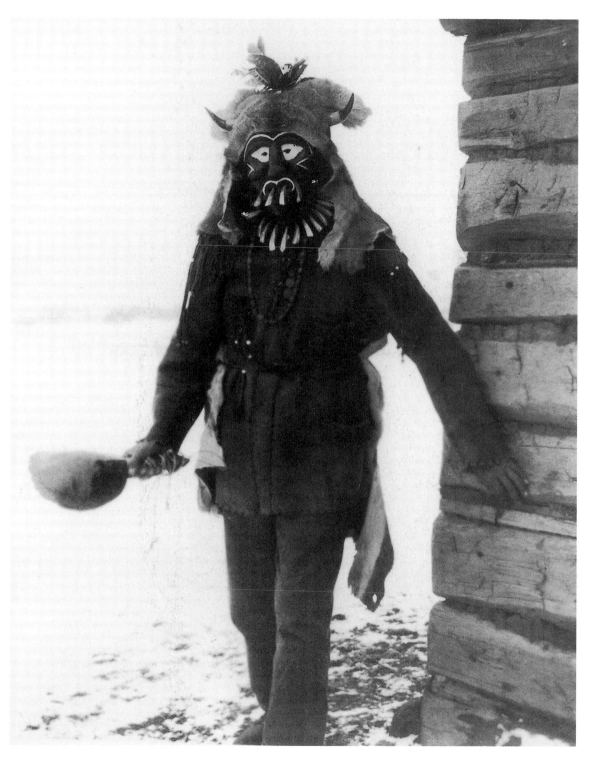

PLATE 35
Six Nations Reservation, Ontario, Canada, 1934. Jerry Aaron, Cayuga, dressed for a Long House ceremony.
Photograph by Frank G. Speck (neg. S4-143998)

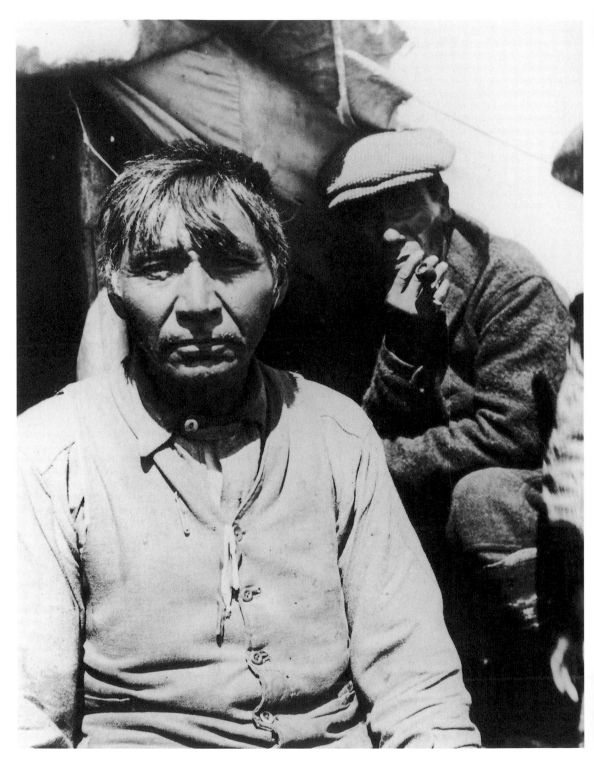

PLATE 36
Pakuashipi (St. Augustine), Quebec, Canada, 1935. Old Jerome, medicine man and singer of the Innu (formerly the Naskapi).
Photograph by Frank G. Speck (neg. S4-143991)

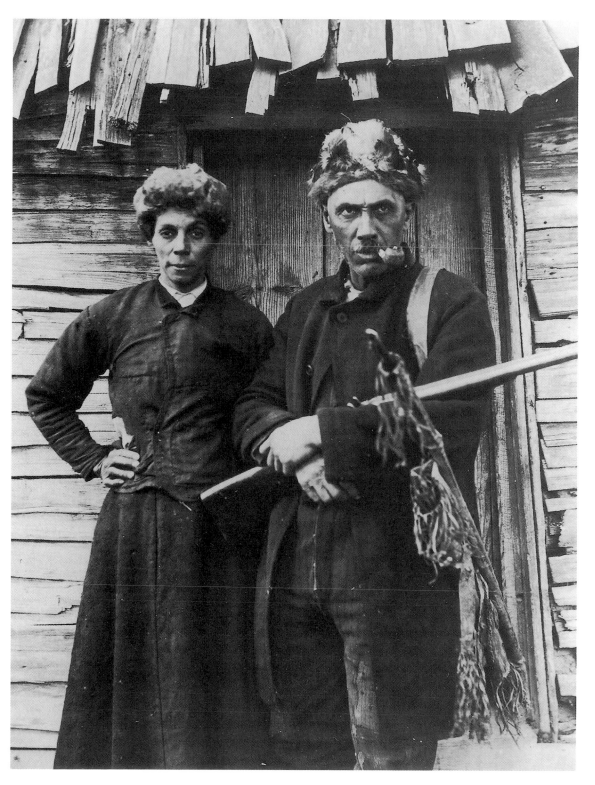

PLATE 37
Delaware/Maryland, ca. 1937. Nanticoke couple pose for the camera in front of their house.
Photograph by Frank G. Speck (neg. S4-143997)

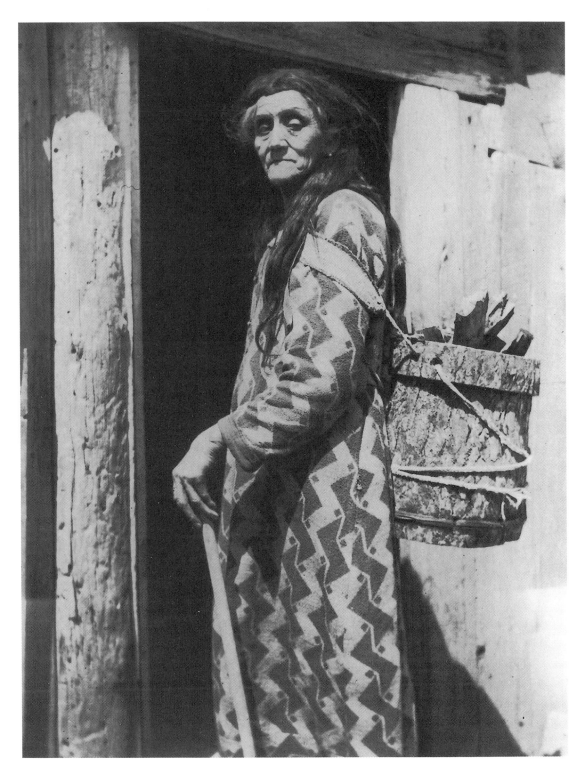

PLATE 38
Six Nations Reservation, Ontario, Canada, 1938. Wife of Sadegohes, Cayuga, carrying fire-wood.
Photograph by Frank G. Speck (neg. S4-143999)

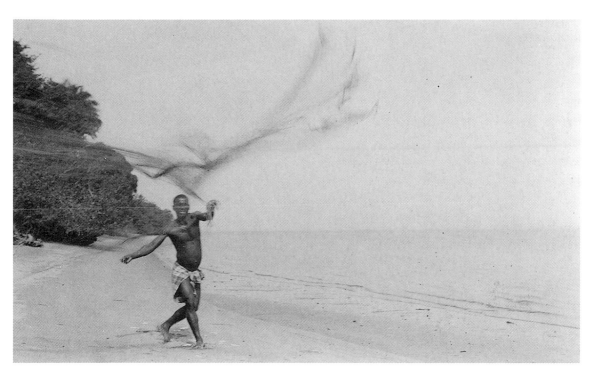

PLATE 39
Yoni, Sherbro Island, Sierra Leone, 1937. The use of a cast net, usually deployed from a canoe, is demonstrated on the beach at Yoni.
Photograph by Henry U. Hall (neg. S4-24909)

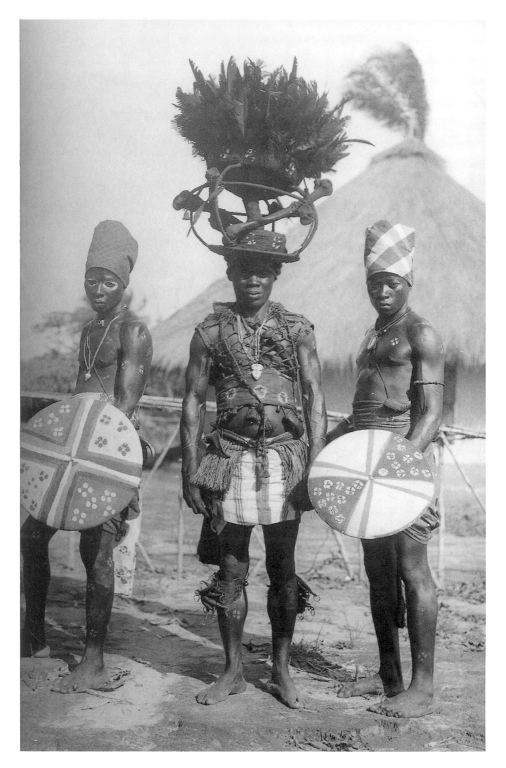

PLATE 40

Shenge, Sierra Leone, 1937. Officials of a Sherbro Secret Society. The man in the center is known as the "Taso." The feathers in his headdress are supported by the thigh bones of his predecessors.

Photograph by Henry U. Hall (neg. S4-24837)

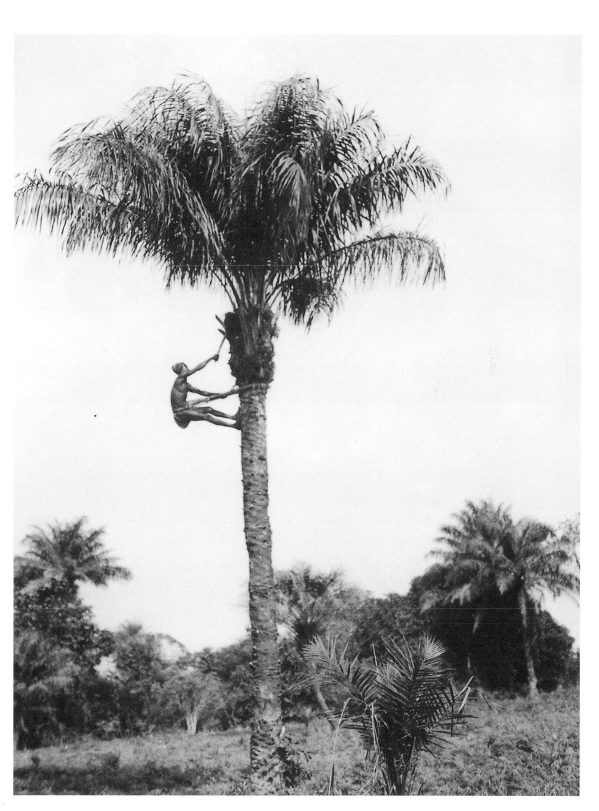

PLATE 41
Yoni, Sherbro Island, Sierra Leone, 1937. Man cutting palm nuts.
Photograph by Henry U. Hall (neg. S4-24946)

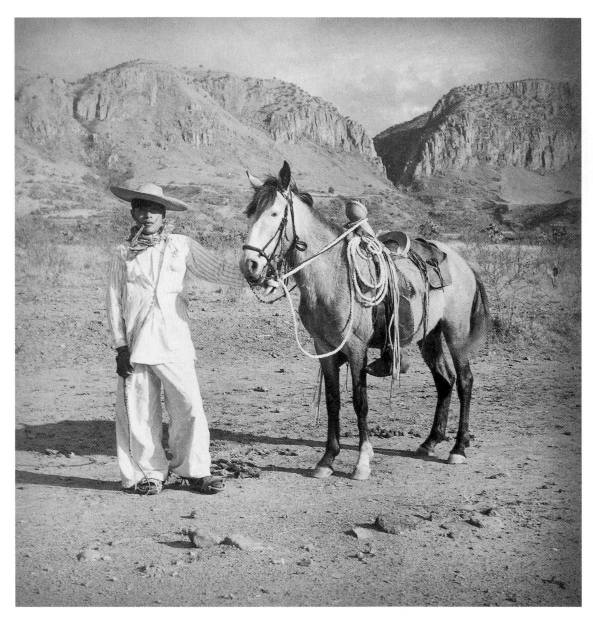

PLATE 42
Xoconostle, Durango, Mexico, 1948. Southern Tepehuan man and horse.
Photograph by J. Alden Mason (neg. S4-49976)

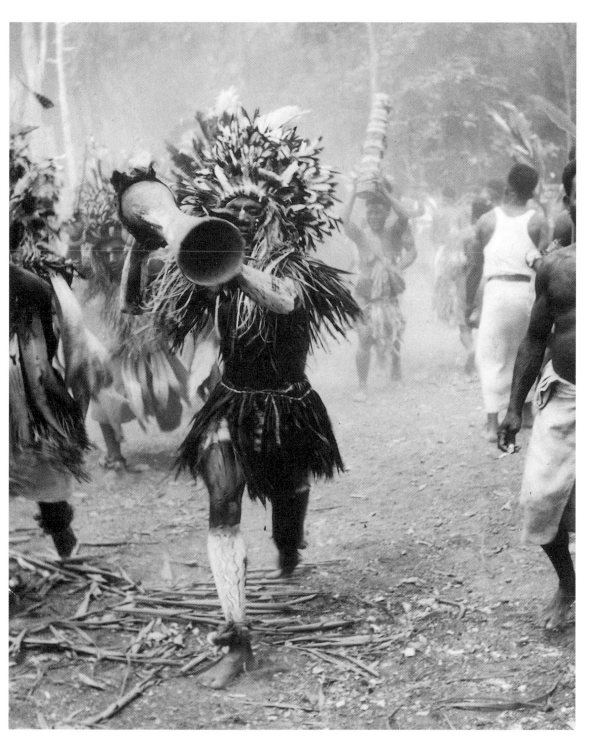

PLATE 43
Hoskins Peninsula, New Britain, 1954. Nakanai dancer with drum emerging from a cloud of dust. The ceremonies in honor of the dead are the most important ritual event in Nakanai society.
Photograph by Ward H. Goodenough (neg. 57313)

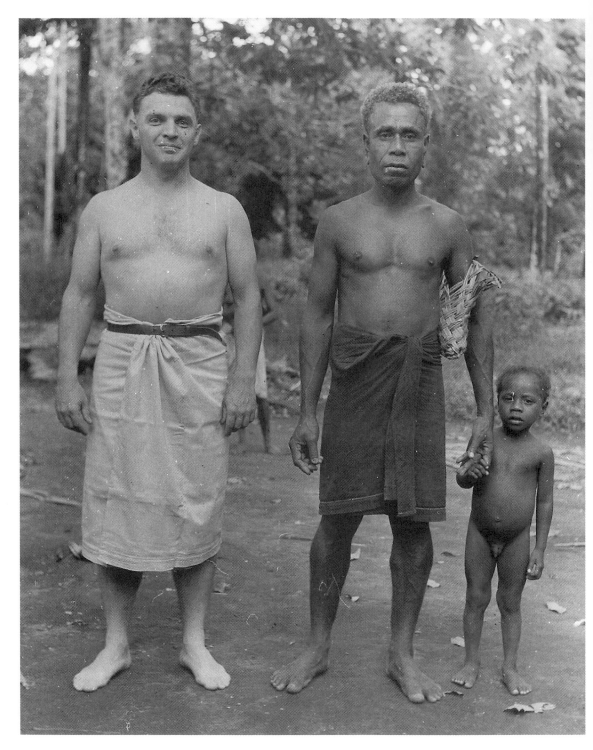

PLATE 44
Hoskins Peninsula, New Britain, 1954. Ward Goodenough (left) and Nakanai informant.
Photograph by Ann Chowning (neg. S4-60279)

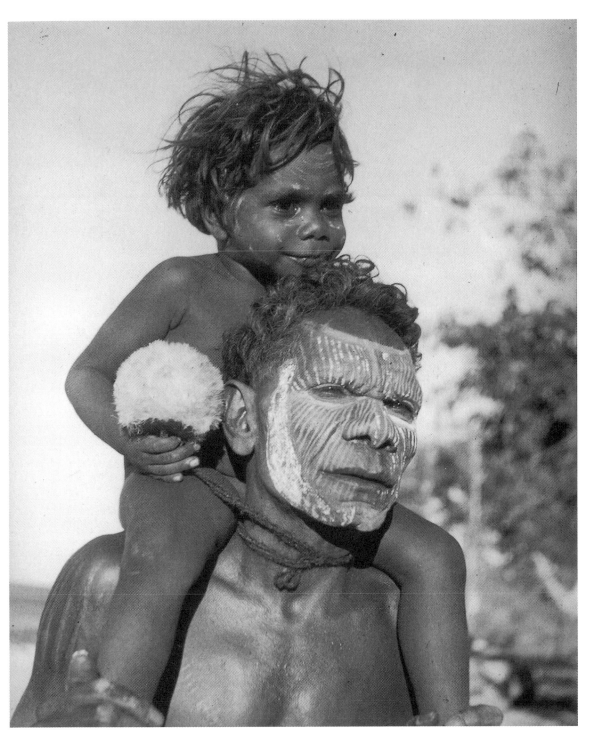

PLATE 45
Snake Bay, Melville Island, Australia, 1954. Tiwi man with painted face and child.
Photograph by Jane Goodale (neg. 67903)

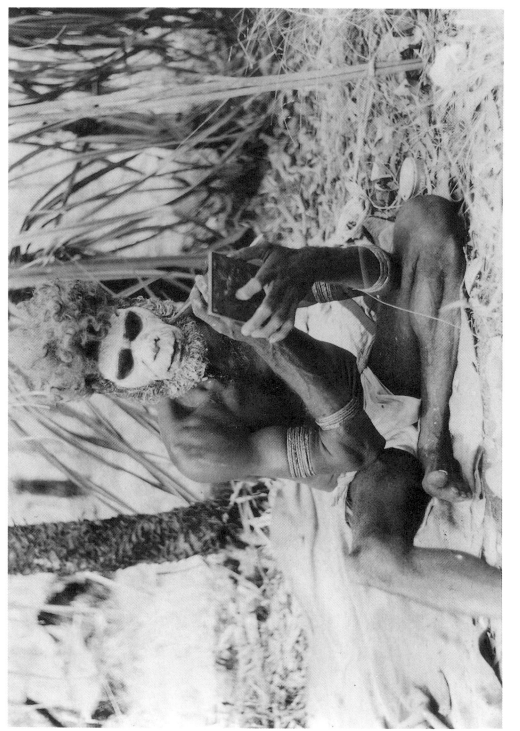

PLATE 46

Snake Bay, Melville Island, Australia, 1954. Tiwi man painting himself for a funeral ceremony. Painting the body and face allows the mourners to disguise themselves from the spirit of the deceased before the final dance. Photograph by Jane Goodale (neg. 70911)

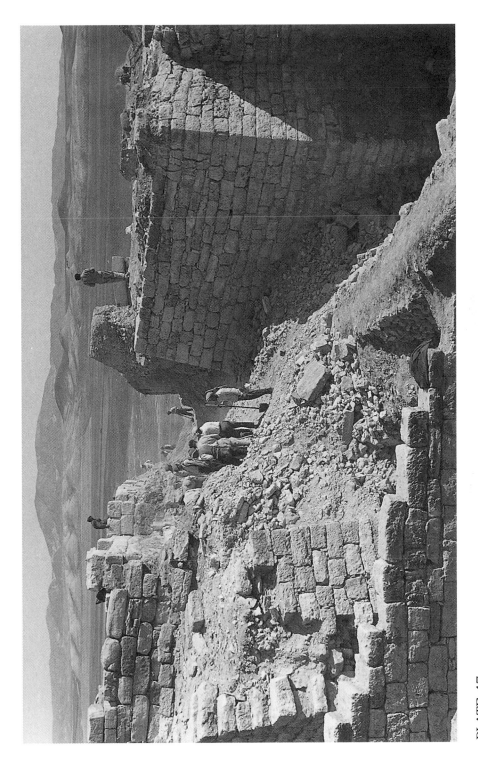

PLATE 47
Gordion, Turkey, 1955. Looking south through the main gateway to the city.
Photograph by Rodney S. Young (neg. R245-8)

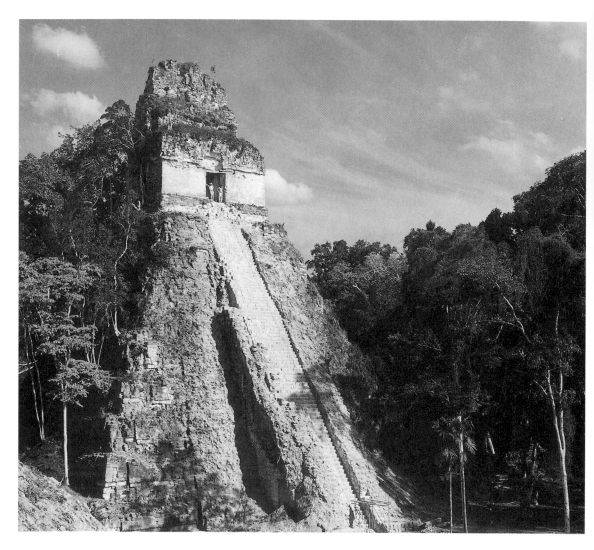

PLATE 48

Tikal, Guatemala, 1959. Temple I after clearing and partial restoration. At 155 feet in height, this structure dominates the Main Plaza, the focal point of Tikal. Tikal is one of the largest cities of the Ancient Maya.

Photograph by William R. Coe (neg. 59-4-81)

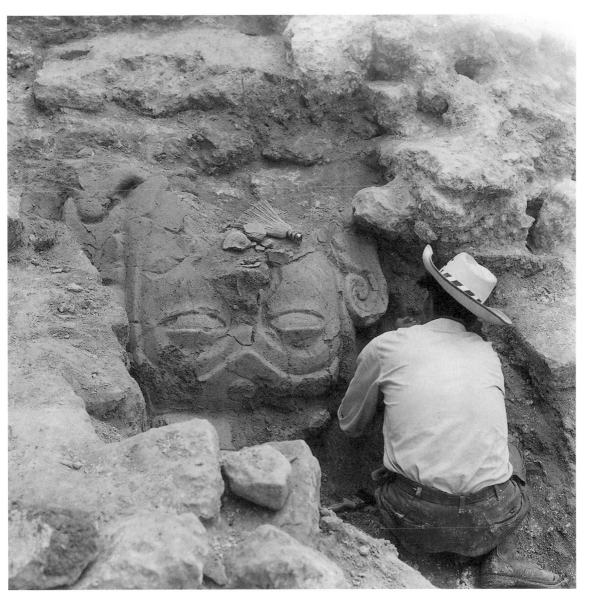

PLATE 49
Tikal, Guatemala. An upside-down sculptured face comes to light in the North Acropolis. The
Maya commonly built new structures over existing architecture.
Photograph by William R. Coe

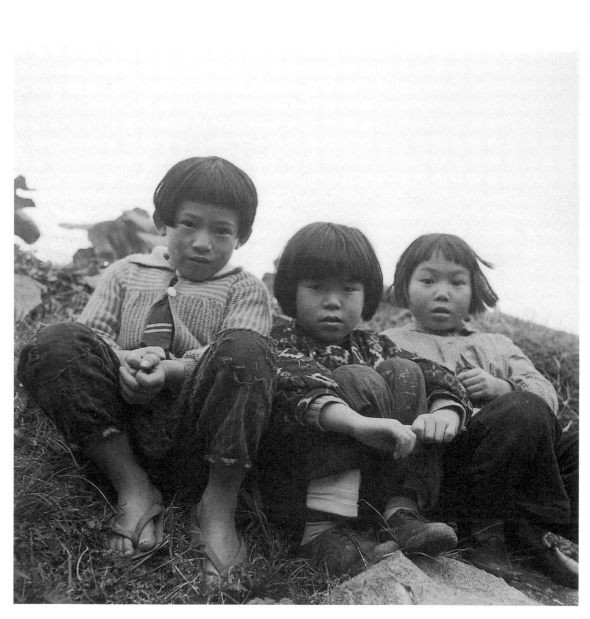

PLATE 50
Hanasi, Kyoto Prefecture, Japan, 1956. Three children from a mountain village.
Photograph by Carleton S. Coon (neg. S4-67319)

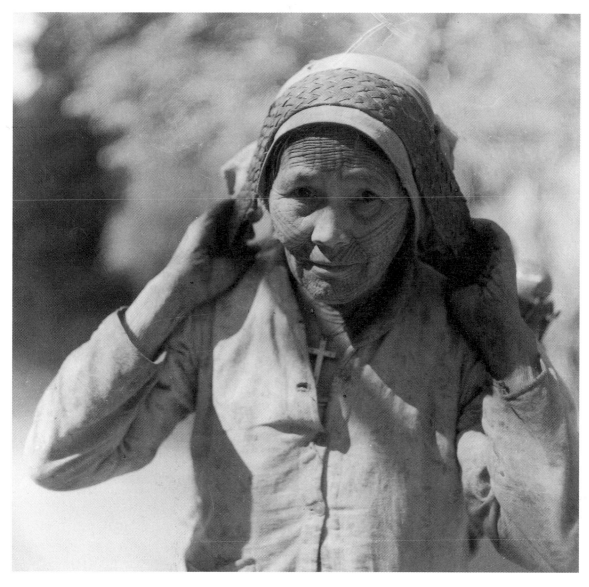

PLATE 51
Pwo-Ai, Taipei County, Taiwan, 1956. Atayal woman carries a load strapped to her forehead.
Note tattoos on face.
Photograph by Carleton S. Coon (neg. S4-67539)

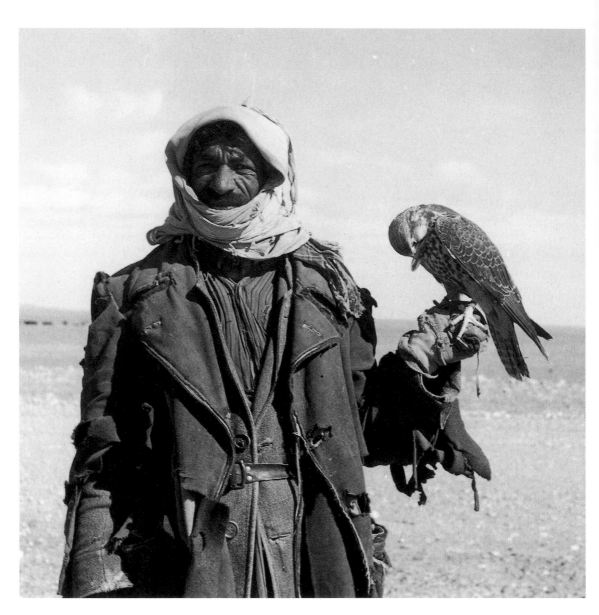

PLATE 52
Northwestern Saudi Arabia, 1952. Ruwala (Bedouin) hunter with falcon.
Photograph by Carleton S. Coon (neg. S4-50202)

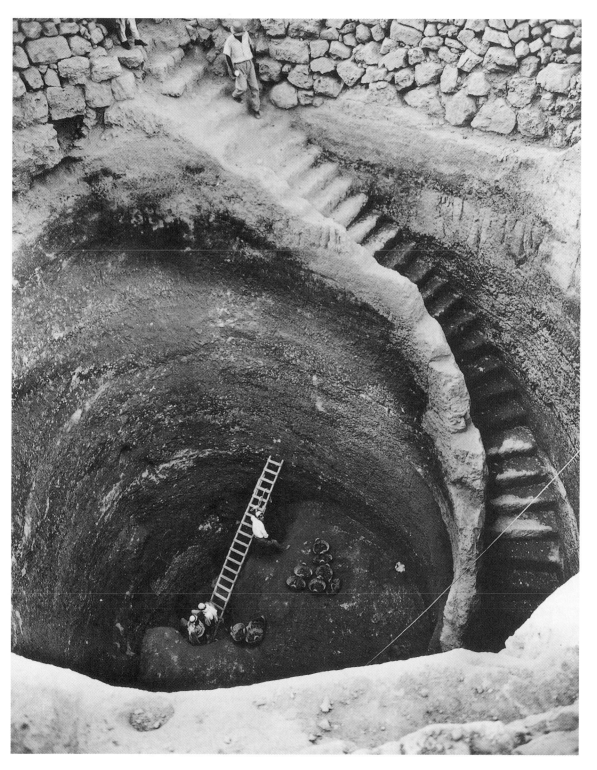

PLATE 53
El Jib (Gibeon), Jordan, 1958. The pool of Gibeon, cut to a depth of 82 feet in solid rock. A circular stairway of 79 steps led from the top to the spring at the bottom.
Photograph by James B. Pritchard (neg. S8-62640)

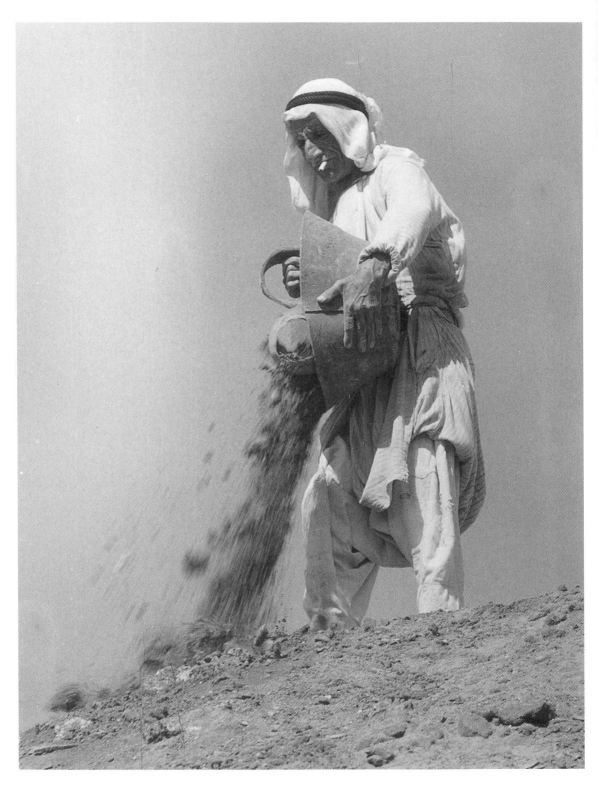

PLATE 54
El Jib (Gibeon), Jordan, 1962. A workman, cigarette in his mouth, empties his dirt basket.

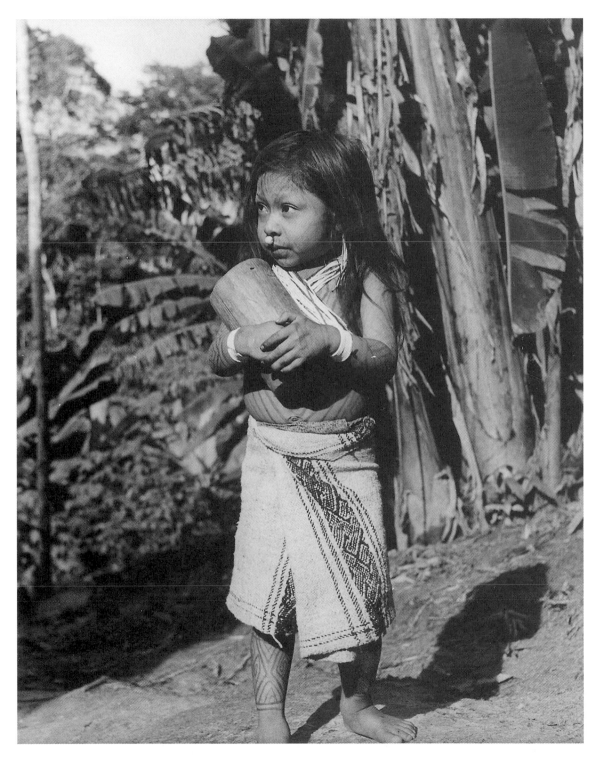

PLATE 55
Maneya, Upper Curanja River, Peru, 1957. Baxi, a Cashinahua girl with her wooden doll (note the carved eyes and mouth). The designs painted on her body fade after about a week.
Photograph by Kenneth M. Kensinger

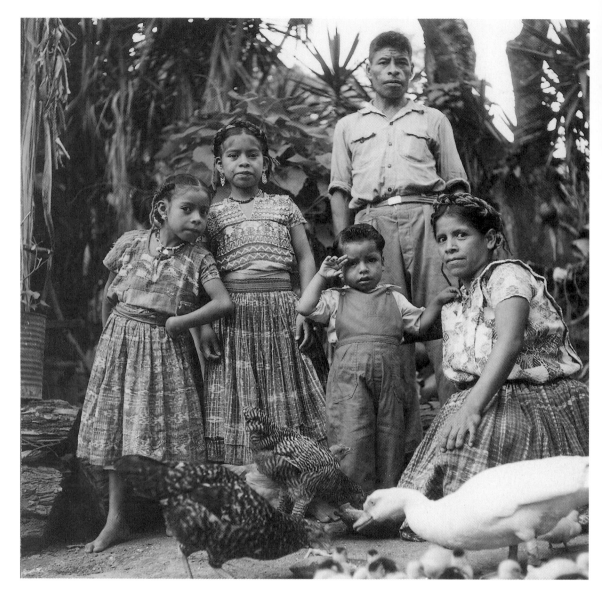

PLATE 56
Chinautla, Guatemala, 1955. A modern Maya potter and her family in their courtyard.
Photograph by Ruben E. Reina

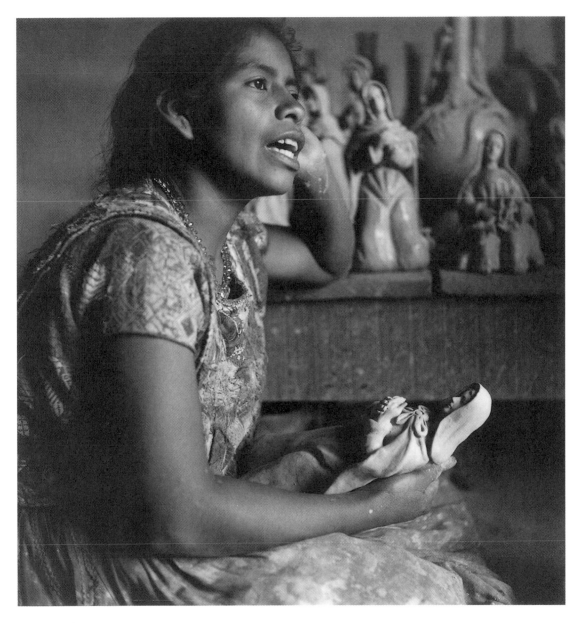

PLATE 57
Chinautla, Guatemala, 1975. Maruca Luis, a modern Maya potter, with her non-traditional
creations.
Photograph by Ruben E. Reina

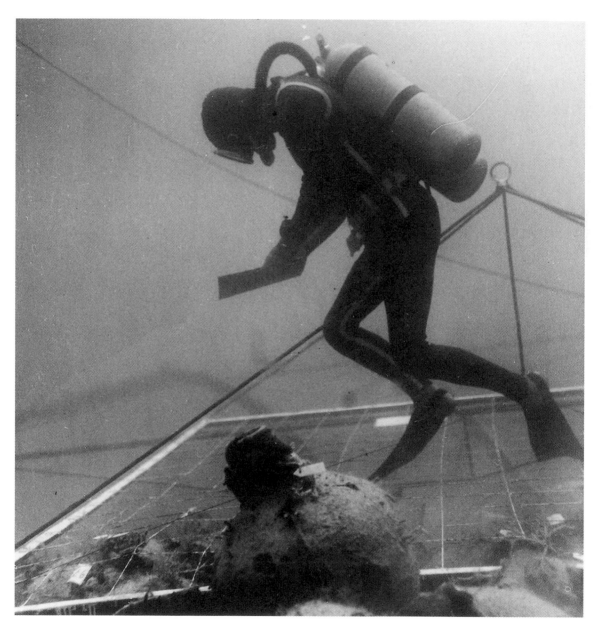

PLATE 58
Cape Gelidonya, Turkey, 1960–61. Underwater archaeologist takes notes and tags objects dur-
ing the excavation of one of the oldest shipwrecks ever found (14th to 13th century B.C.). This
was the first excavation to adapt the standards of land archaeology to underwater remains,
including the use of a grid system to record finds.

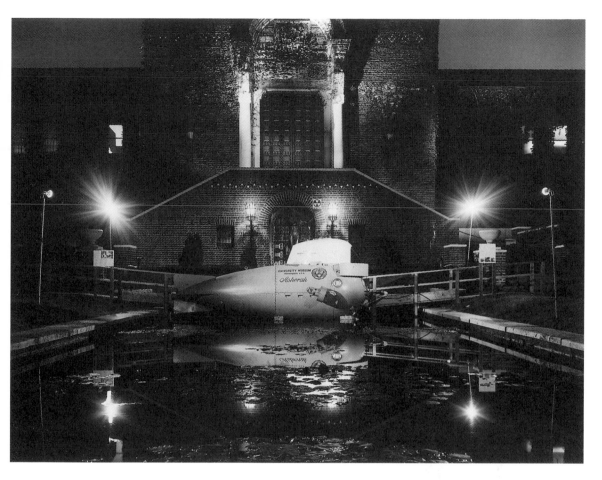

PLATE 59
Warden Garden, University of Pennsylvania Museum, Philadelphia, 1967. Submarine
"Asherah" displayed at the Museum's main entrance. This two-person submersible craft was
built by the Electric Boat Company, a Division of General Electric, and outfitted with a camera
to document the sea floor. Its crew employed arms or hooks to hoist objects from the bottom.
(neg. S4-87503)

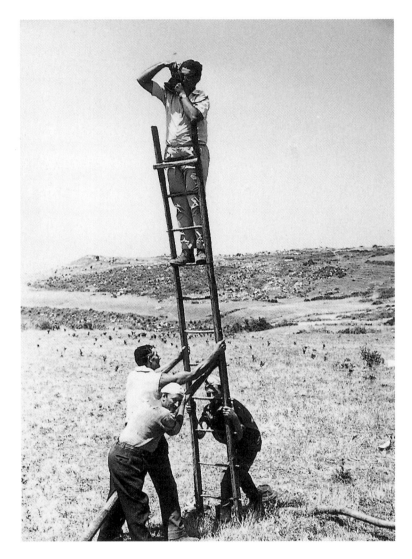

PLATE 60
La Civita near Artena, Italy, 1967. Archaeologists improvise!
Field photography requires skill and a certain amount of inge-
nuity. Lorenzo Quilici is on the ladder.
Photograph by James C. W. Delmege (neg. S4-143992)

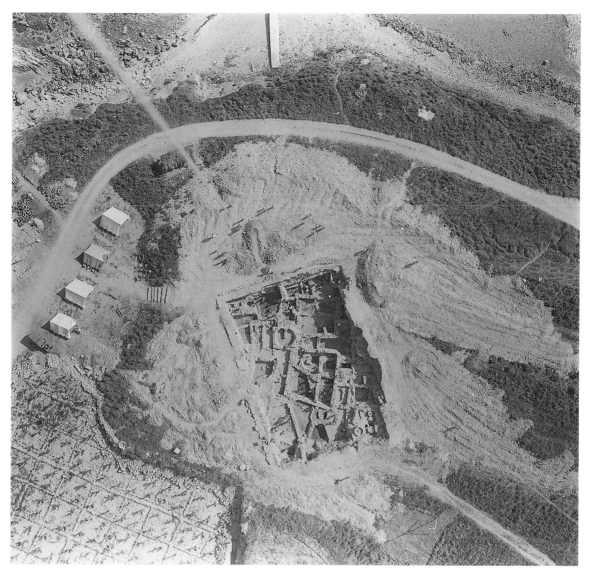

PLATE 61
Sarafand (Sarepta), Lebanon, 1972. The use of low-altitude balloon photography furnishes the archaeologist with an overall view of excavations. Here the balloon flies over ancient Sarepta, an Iron Age Phoenician site.
Photograph by Julian Whittlesey

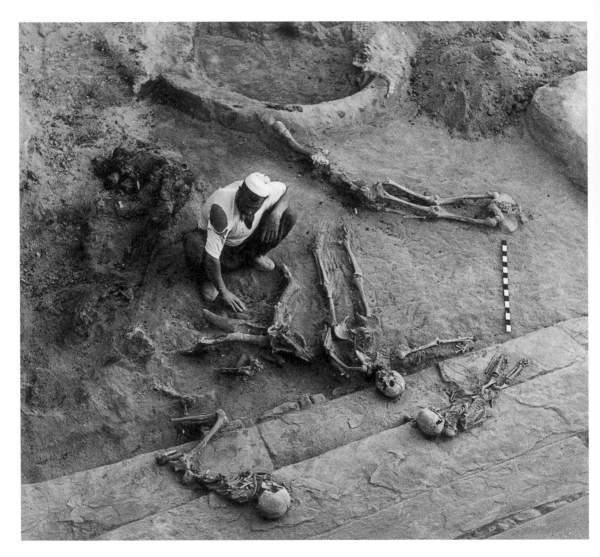

PLATE 62
Hasanlu, Iran, 1962. Victims of a battle that destroyed the city around 800 B.C. These skeletons were found in Burned Building II as left by their attackers. Note the skull and antlers of a red deer in front of the workman.
(neg. S35-78138:1)

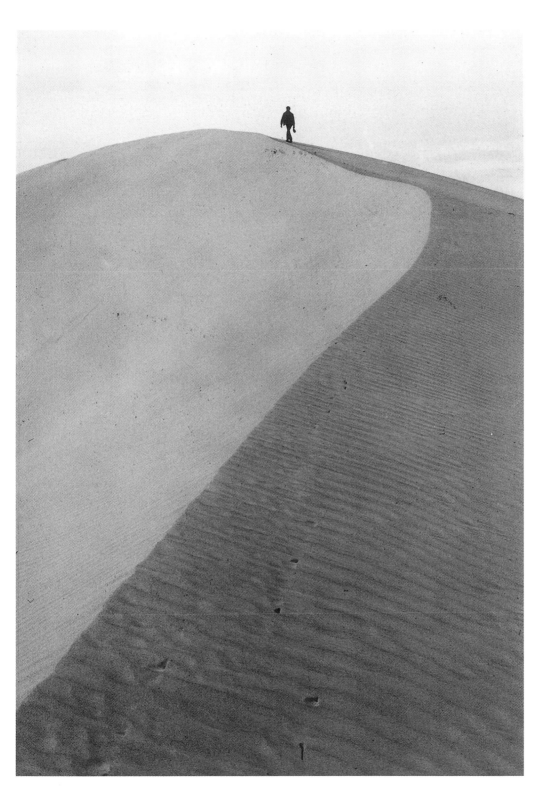

PLATE 63
Seistan, Afghanistan, 1969. Searching for archaeological sites across the desolate
Seistan desert. Though at present devoid of human population, this area was occu-
pied in the past as early as 2000 B.C.